POOLE
PUBS

ANDREW JACKSON

AMBERLEY

First published 2019

Amberley Publishing
The Hill, Stroud
Gloucestershire, GL5 4EP

www.amberley-books.com

ISBN 978 1 4456 9509 9 (print)
ISBN 978 1 4456 9510 5 (ebook)

British Library Cataloguing in Publication Data.
A catalogue record for this book is available from
the British Library.

Typesetting by Aura Technology and Software
Services, India. Printed in the UK.

Contents

Introduction

In central Poole there are thirty pubs, plus an additional seven that are within walking distance of the town centre, assuming you don't mind a fair walk with few, if any, pubs in between. Of the thirty central pubs, twenty-two are situated within the historic Quay and Old Town areas, which is where the main drinking focus is.

Poole is the second largest natural harbour in the world, the largest in Europe, and has a hundred miles of coastline. In fact, the name of Poole comes from the Old English 'Pol', meaning 'pool' or 'creek'. The port itself has a long trading history dating back to Roman times due to its prime position on the harbour.

In medieval times commodities for export, particularly wool, were funneled into Poole from outlying areas of Dorset. Also, it was one of the few ports where merchants could dock, store their goods and display their wares. Consequently, Poole burgeoned from a small fishing village to become an important port, and as a result, the town centre developed around the Great Quay part of the Quay, and the inns developed in this vicinity.

In the seventeenth and eighteenth centuries, trade with Newfoundland was bringing great prosperity to Poole, and as an expression of the town's success, the Guildhall was built in 1761. This resulted in public houses emerging nearby in Market Street.

In 1893–95 the town enlarged and the Quay extended east. Accordingly, public houses sprang up among the warehouses on this part of the Quay around Strand Street and Fish Street. None of these public houses survive today, as much of the area was later demolished in slum clearances.

In the 1930s, public houses continued to proliferate around the Quay, replacing warehouses as they fell into decline.

Poole is still a working port, particularly on the Hamworthy side, where many gleaming Sunseeker yachts, just off the production line, can be seen adjacent to industrial cargo ships moored nearby. This side also includes a ferry terminal.

On the Poole side, the Fishermen's Dock nestles incongruously adjacent to a yachting marina, which houses many luxurious vessels, most of which would have been built across the water at Sunseeker.

The Quay and Old Town has many cobbled streets and alleyways containing historic buildings, some dating back to the twelfth century. This area evokes a chequered maritime history, relating to Newfoundland merchants, pirates, smugglers and press gangs, which is reflected in many of the pubs.

A factor that affected the early development of drinking premises, not just in Poole but throughout the country, was the Beerhouse Act which was passed by the Duke of Wellington in response to the numerous social problems that were being caused by the availability of cheap gin, aka mother's ruin. The intention was to encourage the consumption of beer rather than gin by increasing competition between brewers and lowering the price of beer relative to gin.

The Beerhouse Act allowed anyone to apply for a licence to sell beer and cider (not spirits) from their own home, hence the name public house. This resulted in a massive increase in the number of public houses.

The Act was controversial as many thought it promoted drunkenness. It also meant there was less regulation involved in the issuing of licences.

In 1869, a change in the law brought licensing back under the control of the local justices. This resulted in many alehouses closing or being purchased by breweries and changing to fully licensed public houses.

The Beerhouse Act increased the number of pubs, while, in contrast, the 2007 smoking ban resulted in the closure of many pubs, although the ban has certainly been beneficial in reducing the level of passive smoking.

Poole, like everywhere else in Britain, is suffering greatly from lost pub syndrome, with many perfectly respectable drinking establishments, and quite a few dens of inequity, disappearing off the face of the earth. Also, many traditional pubs have metamorphosed into gastropubs or restaurants/bars as drinking cultures have changed. Another interesting social change occurring at the moment is the move towards gin bars, in a direct reversal of what the Beerhouse Act hoped to achieve.

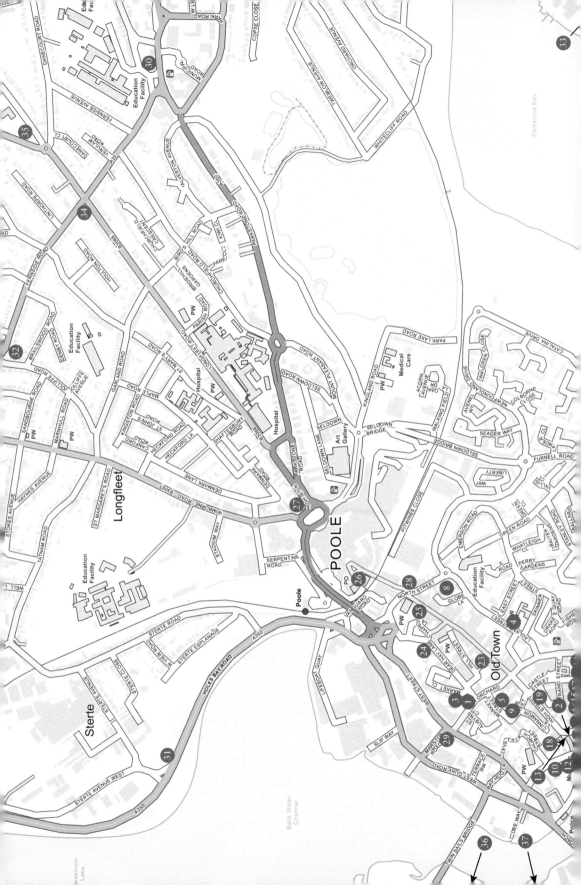

Key

I

The Quay and
Old Town

The Quay and the Old Town have been the catalyst for the historical development of Poole. The very first inhabitants were Iron Age people who survived on the harbour's plentiful supply of oysters, cockles, crabs and fish. This is illustrated by the Iron Age log boat that was discovered in the harbour in the 1960s, and now resides in Poole Museum.

Later in AD 45, the Romans landed at Hamworthy and established a port, which was pivotal in their conquest of South West England; Vikings also landed at Poole, and in 1015 Canute launched an attack on Wessex from Poole.

Transient Saxon fishermen developed an oyster fishery, resulting in the Quay being built on a foundation of a thick bed of oyster shells, but the first real settlers were Norman fishermen.

The Great Quay part of the Quay was the main focus of activity in medieval times, as Poole established itself as an important port.

Many of the medieval foundations and structures remain on this part of the Quay, and this area and the alleyways and streets behind it are the oldest part of the Old Town. However, the overall style of the Old Town is Georgian, as it underwent much redevelopment in the eighteenth century, as the wealthy merchants who had grown rich by trading in Newfoundland started building themselves some impressive mansions to signify their wealth and status.

Between the sixteenth and early nineteenth centuries, numerous merchant vessels left each spring from the Quay to fish in the hitherto unfished waters of the cod-rich Grand Banks of Newfoundland. They traded the cod for other goods and seized opportunities to make vast fortunes.

During this period, others focused on accumulating ill-gotten wealth; pirates were rife between the fourteenth and eighteenth centuries, and then between the seventeenth and nineteenth centuries smuggling came to the fore as the main illicit trade.

The areas behind the East Quay are also considered to be Old Town and there is an Old Town First School and Old Town Community Centre in this quarter. However, this part tended to be occupied by the less wealthy, and a lot of the older buildings

that did exist here have not survived, as they were destroyed in the slum clearances of the 1950s and '60s.

Angel, Market Street

The Angel dates to around 1729 but was rebuilt in 1890. It is within spitting distance of the Guildhall.

The Angel is believed to have first been used as a coaching Inn in 1770. The coach was also called the *Angel*, and travelled to Shaftsbury via Wimborne and Camborne, carrying passengers and light goods.

Bullet marks can be seen in the wall of the Guildhall, and they date back to a murder that took place in 1886, when local man John King was drowning his sorrows.

The recent death of King's father left him as the sole bread winner, supporting his mother and sisters. His father had been a harbour pilot and John King wished to continue in that role using his father's boat. However, he was persistently refused a permit by Alderman Horatio Hamilton, who claimed the boat was unseaworthy.

When Alderman Horatio Hamilton made an appearance on the Guildhall steps, King rushed out of the pub to confront him and, after a heated discussion, ended up launching a salvo of shots at him.

He was initially sentenced to hang, but an angry reaction from those in Poole who sympathized with his plight meant that he was sent to a lunatic asylum instead.

The pub has belonged to Ringwood brewery since 2002.

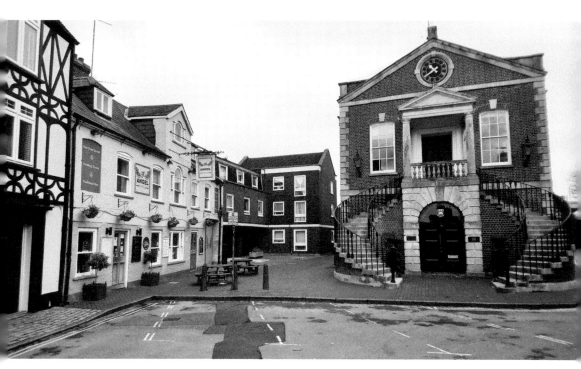

The Angel and Guildhall.

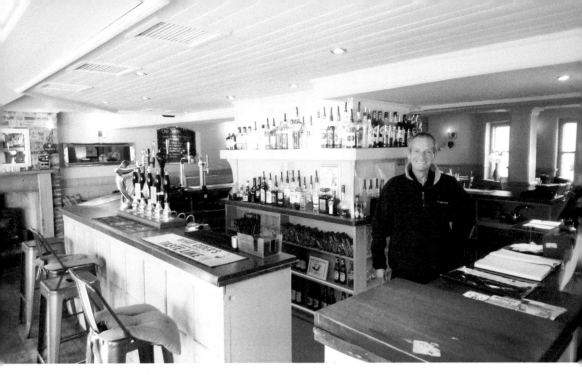

Inside the Angel.

Guildhall

The Grade II listed Guildhall is one of Poole's most historic and iconic buildings. It was built in 1761 by Poole's two Members of Parliament as a symbol of the town's affluence.

The prosperity was due to trade with Newfoundland (see Newfoundland Trade), and many of Poole's great merchant families such as the Lesters, the Garlands and the Jolliffes were building themselves impressive Georgian mansions, many of which still predominate in the merchants quarter of the Old Town, around St James' Church.

The Guildhall looks similar in appearance to the old Custom House, which is now the Custom House Café, as they are both characterised by ostentatious dual staircases.

In the seventeenth century, the Guildhall came to symbolise power and trade. It was a meeting place for Poole's councillors, and there was a police station next door. It was also used as a courtroom, where sentences of public floggings or deportations would frequently be dished out to the unfortunate miscreants.

The ground floor, which is now enclosed, used to consist of open-fronted market stalls, and was used twice weekly as a meat market.

In 1815, after the Battle of Waterloo brought an end to the Napoleonic Wars, the Newfoundland trade collapsed and the town lost its prosperity. During this time, the Guildhall was pressed into service as the parish church, as St James', the church in the Old Town, had been pulled down in 1819 in order to be rebuilt.

In 1885, political reform resulted in town clerk Robert Parr being made redundant. He subsequently made an outrageous compensation claim, which the High Court ordered the Guildhall to pay. The Guildhall tried to increase the rates in order to meet the bill, but was met with a flat refusal from the householders, meaning the Guildhall was unable to settle the claim. The High Court ruled that the Guildhall had to be handed over to Mr Parr as payment.

Robert Parr was obviously a very bitter man, so to rub salt into the wounds, he rented the Guildhall to a farmer who kept cattle in it. Meanwhile, the council were unable to feed the poor, or buy gas for the streetlights.

In 1944, the Guildhall became a kind of NAAFI (i.e. a canteen and meeting room) for American servicemen preparing for D-Day and was also used as washrooms.

After the war, the washing facilities were left in place for use by local people living in the tenements, where washing facilities were virtually nonexistent. These replaced the previous slipper baths (a place where people could wash), which had been flattened by the Luftwaffe. This usage of the Guildhall was only discontinued in the 1960s after the slum clearances (see Slum Clearances).

After the war, it was used as an art school, and then in the 1960s it housed Poole Museum, before the museum moved to its current site on the Quay in 1991.

The Guildhall was unused and falling into a state of disrepair between 1991 and 2007 until the rules governing civil marriages were altered, meaning it could be put to good use once again as the Borough of Poole's Register Office.

The Antelope, Lower High Street

The Antelope dates back to 1465 and is considered to be the oldest pub in continual use in Poole, although this is disputed by the King's Head (see King's Head). However, it can certainly claim to be the oldest hotel in Poole.

It was originally named the Antelope Inn, and was a Royal Mail coaching inn, which, in addition to the mail, took passengers to and from London, Bristol and Bath.

Some of the original artefacts of the building still remain, such as the massive Purbeck stone fireplace in the bar and the wooden beams.

The Antelope.

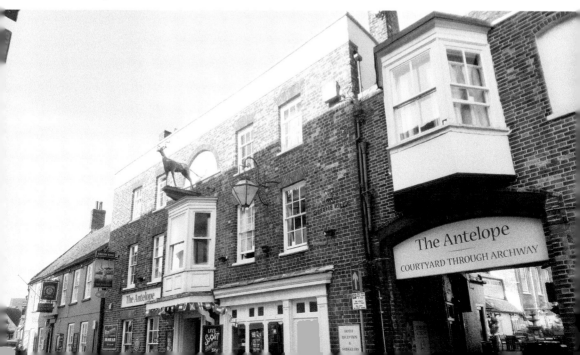

Left: The bar of The Antelope. The wooden beams of the ceiling are part of the original building and date back to 1465.

Below: The building at the back of The Antelope has been used as a brewery, a cargo storage room for Newfoundland traders and even as a place for French 'Johnny' onion sellers to store their onions.

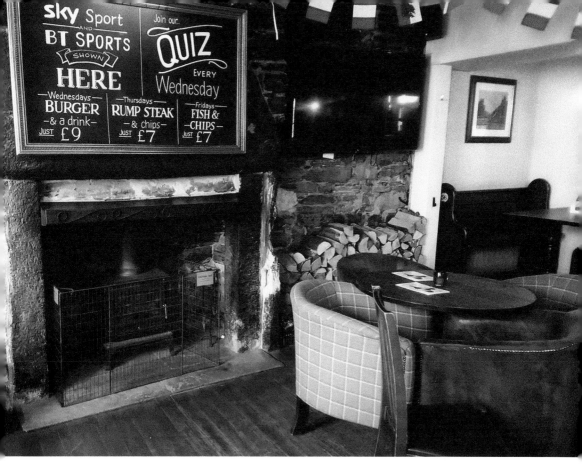

The fireplace of The Antelope is also an original fixture dating back to 1465.

To the rear of the hotel is a building that has seen many different uses over the years. At one time it was a brewery providing beer for the pub. Other uses have included cargo storage for the Newfoundland trade, and an onion storage depot for the 'Johnny Onion' sellers from Roscoff in Brittany.

In the early nineteenth century, the building was refurbished with a Georgian frontage and a second floor was added. During this period the name was also changed to the Antelope Hotel, to distinguish it from another establishment that had opened in New Street called the New Antelope Inn. Later the prefix 'Old' was added, so it became the Old Antelope Hotel, thus distinguishing it further.

The upstairs rooms currently offer bed and breakfast accommodation, but in the past rooms have been used for meetings, as a ballroom, a sail loft and a judge's court.

In 1830, Charles X of France was ousted in a bloodless coup shortly after the French Revolution, known as the July Revolution or the Second French Revolution. He was succeeded by his cousin who became Louis Phillipe I.

Charles X sought refuge in England, landing in Poole Harbour at Hamworthy opposite Poole Quay. He was offered hospitality further along the coast at Lulworth Castle by Dorset's principal Catholic, Joseph Weld, which he accepted. Meanwhile his family and courtiers stayed at the Antelope Hotel. They included the Duchess de Berri, the Dauphin, the Duchess d'Angouleme and the Duke of Bordeaux.

At one time the pub was used as a meeting point for the Poole lifeboat crew, which mainly consisted of local fishermen. They would then be transported 5 miles by horse-drawn coach to Sandbanks, where Poole's first lifeboat station was established in 1865. Sandbanks, at this time, wasn't the expensive real estate it is now, but a desolate area of sand dunes. Fortunately, given the distance and the time involved in getting there, the lifeboat station was moved to the Quay in 1882 (see RNLI Museum).

The Antelope was also the headquarters for a unit of Second World War commandoes known as the Small Scale Raiding Force. On one raid they were detailed to attack the Atlantic Wall, which was a series of fortifications built by the Nazis along the coast of Continental Europe. They were intercepted by German commandoes en route, and in the ensuing skirmish, their leader, Captain Gus March-Phillips, was killed.

The Antelope entertained another royal in 1856, in the form of a fourteen-year-old Edward, Prince of Wales, later to become Edward VII. He was touring Dorset with his father, Prince Albert.

The present Prince Charles also visited The Antelope for lunch while his Royal Navy training ship, HMS *Schimitar*, was moored at the Quay.

Royal National Lifeguard Institution (RNLI) in Poole
Operational Lifeboat Station
Poole is the busiest lifeboat station in the country in terms of the number of call outs. It covers Poole Harbour, which has 100 miles of shoreline, and includes Poole Bay, which has 7 miles of beaches from Sandbanks to Southbourne. These popular beaches result in a large number of call outs, involving holidaymakers and day trippers.

The operational lifeboat station is situated on the western aspect of the quay near the lifting bridge. They operate two inshore lifeboats, a B Class Atlantic 85 and a D class, which are launched from a boat house almost underneath the bridge.

There is also an all-weather Tyne class lifeboat situated nearby.

Poole's lifeboats in their pens ready for action.

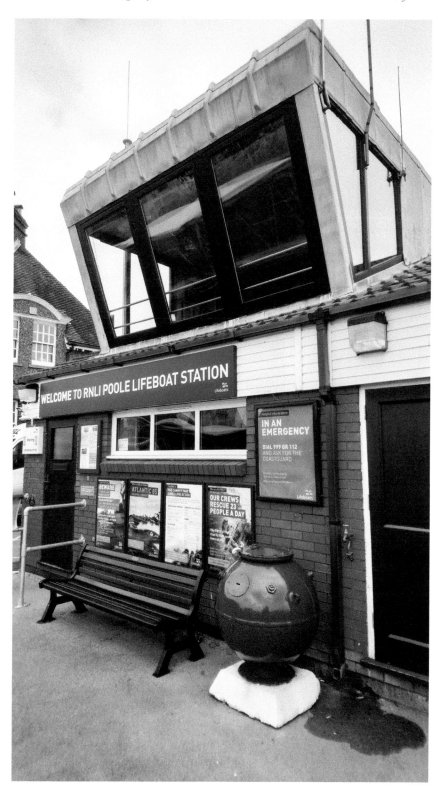

Poole's operational lifeboat station.

RNLI Training College

Poole became the headquarters of the RNLI in the mid-1970s, and its offices house the administration and support staff.

The RNLI Training College, which was opened in 2004 by the Queen, is also based in Poole. It trains lifeboat crews and beach lifeguards from the whole of Great Britain and Ireland.

A later addition, in 2015, was the All Weather Lifeboat Centre, which boasts a sea survival pool where capsize drills can be practised, as well as drills concerning engine room fires and other emergencies. There is also a lifeboat bridge simulator, which simulates the dramatic conditions that lifeboat crews must regularly face at sea.

It is a frequent occurrence to see lifeboat crews from various parts of the country on training manoeuvres throughout the harbour.

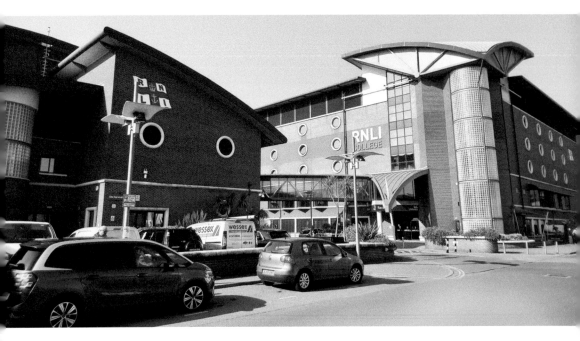

Above: Part of the vast RNLI Complex.

Left: The RNLI sculpture by Sam Holland incorporates steel waves at the base, which are engraved with the names of 778 lifeboat crew who have sacrificed their lives saving others.

The RNLI on a training manoeuvre in the quay.

RNLI Museum
Situated on the far reaches of the Eastern Quay next to Fishermen's Dock is the old lifeboat station, which is now a museum. It was built in 1882 and was in use until 1974, when it moved to Lilliput Marina.

In 1988, the lifeboat station moved again to its present site by the lifting bridge on the far western aspect of the Quay.

The Lifeboat Museum.

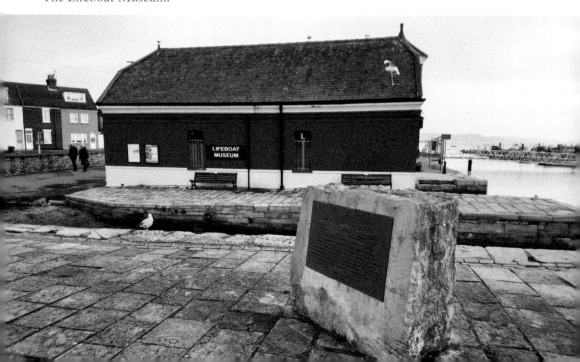

Hero of Dunkirk

The lifeboat, which now takes centre stage in the Lifeboat Museum, played a heroic role in the Dunkirk evacuation on 30 May 1940.

Thomas Kirk Wright was built in 1938 and is now one of only two surviving surf class lifeboats. She was Poole's first motorised lifeboat.

On the first day of the evacuation she was the first lifeboat to make it to Dunkirk. She made three trips over four days, rescuing many troops. On the final return journey, she was loaded with French troops, and came under heavy fire, which caused widespread damage to the boat. Although, no one was hit, she had to limp home on only one engine.

After extensive repairs she returned to lifeboat duty in Poole, before retiring in 1962.

RNLI Beach Lifeguards

There are fourteen RNLI lifeguarded beaches covering a 7-mile stretch from Sandbanks to Southbourne, which are patrolled by beach lifeguards on a seasonal basis.

Blue Boar, Market Close

The current building was built around 1759 and was originally the home of a wine merchant, before becoming licensed premises as the Conservative Club in the 1900s. It returned to its former residential use when the Conservative Club moved elsewhere in the 1920s.

In the 1960s, the basement of the building became the Cellar Club, and it developed as a popular club staging live music. Many bands that subsequently became famous have played here including the Stranglers and Manfred Mann. Rod Stewart has played at this venue in two separate bands – Shotgun Express and Steam Packet. Local Poole lad Greg Lake, of Emmerson Lake and Palmer, has also appeared.

The Cellar Club eventually closed, and the building lay dormant for a while, before briefly becoming the Market Arms.

The Blue Boar.

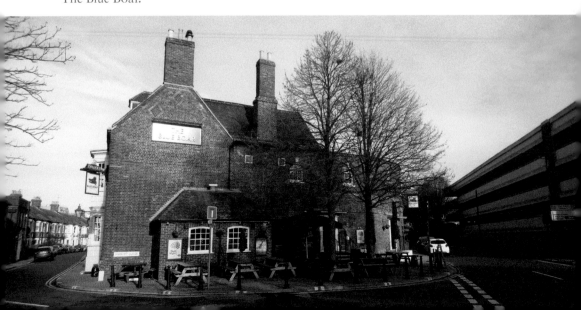

In 1994, the Blue Boar opened under the stewardship of the tough ex-copper Jim Kellaway and his wife Stella of Lord Nelson fame (see Lord Nelson).

The Lord Nelson was originally called the Blue Boar, as Blue Boar Lane was the name of the alleyway between the Jolly Sailor and The Lord Nelson on the Quay. It was one of the grim-looking alleyways leading from the Quay, where one could well imagine press gangs lurking, which, in days gone past, would have been very busy finding new 'volunteers' for the Royal Navy (see Press Gangs).

Jim and Stella maintained the link with their old pub, as they made themselves at home by bringing their collection of shipwreck artefacts, which, along with other souvenirs from various relatively recent military campaigns such as the Falklands and the Gulf, have turned the three floors of the pub into a kind of maritime museum.

The Blue Boar is yet another Poole pub that is believed to be haunted. Staff have reported seeing mysterious murky figures disappearing through walls, others have heard the demented barking of demonic spectral dogs, while some sense mysterious aromas, which seem unrelated to the situation.

It is a Fuller's Pub, which is unusual in the Poole area, as of course that brewery tends to be more commonly associated with London pubs.

The Cockleshell, Lagland Street

The original pub at this site was built in 1789, and was named the Royal Sovereign, after HMS *Royal Sovereign*, a famous 100-gun warship built in 1786. The warship distinguished herself in the Napoleonic Wars, and in 1805, renamed as HMS *Captain*, was the first ship to see action at the Battle of Trafalgar.

The Cockleshell.

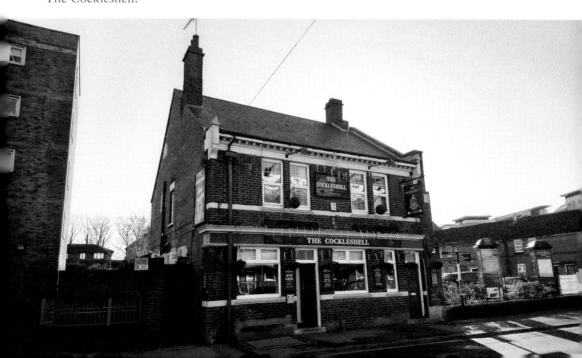

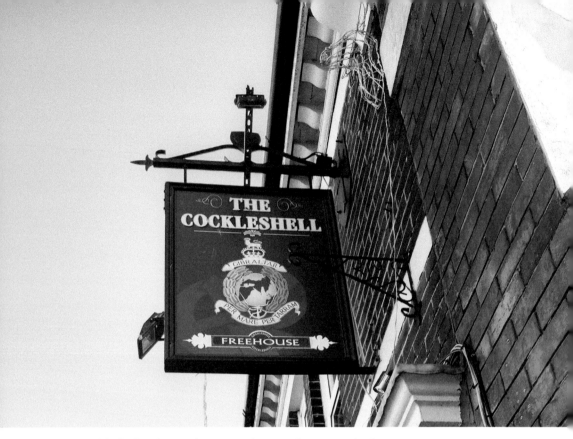

The Cockleshell pub sign featuring the Royal Marines badge.

The pub became the Shipwrights Arms, then the Ship Inn and then later the Old London Tavern. The Old London Tavern was rebuilt in 1820 as a coaching Inn called the New London Tavern, which operated a coach taking customers to Weymouth and Lymington.

The pub was renamed The Cockleshell in 2000, as Poole Bay is known for its cockles. The name also pays homage to the Cockleshell Heroes, who were ten Poole-based Special Boat Squadron (SBS) Royal Marines, thus explaining the Royal Marines badge on the pub sign (see Royal Marines and Cockleshell Heroes).

This area of the Old Town towards the East Quay, where The Cockleshell is situated, was at one time inhabited by dockers and seamen living in slums, and The Cockleshell's Victorian frontage has stood isolated amidst a backdrop of urban regeneration.

The pub is owned by Eldridge Pope Brewery of Dorchester.

Slum Clearances

After the boom years of the Newfoundland trade, Poole suffered from an economic slump throughout most of the nineteenth century. This was further compounded by the unemployment and poverty that were a nationwide problem in the 1920s and '30s.

The labyrinth of narrow back streets and alleyways leading from the Eastern Quay into the Old Town were overcrowded, damp, rat-infested slums, and during the 1920s and '30s this quarter was also dominated by an enormous gasworks, which added to the general misery, as the whole area was shrouded in coal dust and had an accompanying sound of clanking machinery.

However, in the decades after the war, many major national companies were attracted to the town, resulting in 10,000 more homes being built in Poole between 1946 and 1966.

A major slum clearance scheme was also taking place during the same period, as over a 1,000 condemned homes, mainly in the Eastern Old Town area around Strand Street, Castle Street, East Street, Lagland Street and South Road, were demolished, as Poole Council managed to succeed where the Luftwaffe had failed and destroyed the tenements and dwellings that had seen people through two world wars.

The occupants were rehoused by the council as these dwellings were replaced with four tower blocks, and a further two were built close to the town centre in Sterte.

Most of the buildings that were demolished dated back to before 1850, and some say that much of Poole's medieval architectural heritage was also destroyed.

Royal Marines

The Royal Marines have had a base in Hamworthy, Poole, for many years. The base was built in 1942, as RAF Hamworthy, and used as a flying boat base (see Flying Boats).

In 1944, the base was handed over to the Royal Navy for use as a training centre for the D-Day landings and was renamed HMS Turtle.

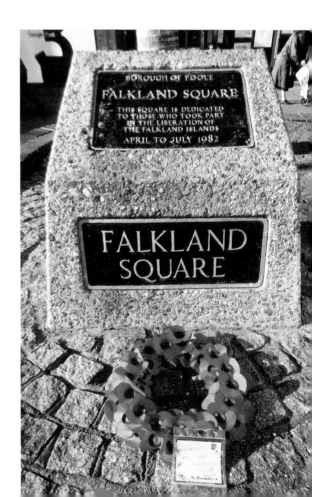

Falkland Square.

The Royal Marines then took over the base in 1954, and at its peak in 1994, 600 Marines were based there, rising to peaks of a 1,000 during the build up to operations.

In 1985, Margaret Thatcher visited the base to award battle honours, and personally review the Royal Marines and Special Boat Squadron (SBS) in recognition of their contribution to the Falklands War, in particular the retaking of South Georgia and East Falkland. The Royal Marines were also awarded the Freedom of the Borough of Poole.

The pedestrianised square outside the Dolphin Shopping Centre has been named Falkland Square, and there is a memorial dedicated to all those who served their country in the Falklands War.

Today, there is still a Royal Marine presence in Hamworthy, and the Special Boat Squadron (SBS) have four squadrons based in Poole.

Cockleshell Heroes
The Cockleshell Heroes were ten Poole-based SBS Royal Marines who carried out a daring raid during the Second World War.

The purpose of the raid was to disrupt German merchant shipping in the French port of Bordeaux, which the Royal Air Force had failed to accomplish, despite repeated bombing attacks. The SBS achieved their aim by planting magnetic limpet mines on the hulls of the ships below the waterline.

Out of the ten men in five canoes who took part in the operation, only two survived. They evaded capture by travelling through occupied France, on to Spain and then Gibraltar.

The canoes they used for the raid were nicknamed cockleshells, as they folded up into the shape of a cockleshell. These were built in Poole (see Boatyards), and could be launched under water from a submarine. The training for this was carried out in Poole Bay.

The Crown, Market Street
The Crown is a Grade II listed building, which started life as the Crowne Inn in 1697, before becoming the Crown Hotel in 1747. It then became the Crown Tavern in 1789, before reverting to the Crown Hotel.

It is known as the Crown Hotel for the purpose of those booking hotel accommodation, but tends to be known generally as The Crown, and that's the name on the pub signage.

It was a coaching inn providing services to Gillingham, Bridport and Dorchester, as well as in the opposite direction to Bournemouth and Christchurch.

During the 1960s it was a rough backstreet cider bar popular with Royal Marines and was the scene of numerous fights and smashed windows.

In 1966, builders who were converting the old stable block into a nightclub experienced some strange happenings, in the form of a piano playing itself and a strange floating fluorescent mist accompanied by the sound of children playing in the deserted courtyard below. It is also said that children can be heard screaming in an area that relates to a hidden attic room that was found by the same builders.

The present landlady has never heard or experienced any of these ghostly phenomena, but did relate stories she'd heard of milkmen refusing to deliver milk to the back of the building due to the unnerving experience of hearing blood-curdling screams.

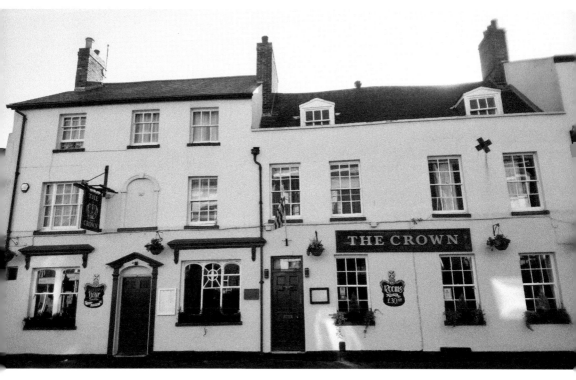

The Crown.

Enjoying a pint in The Crown.

The story is that a landlord of the inn, in the seventeenth century, had two deformed twin children, whom he kept out of sight in the hidden attic of the stable block before murdering them.

Custom House Café, The Quay

The Custom House Café is a Georgian-style, Grade II listed building. It was granted a change of use certificate in 1995, and turned into a seafood restaurant and bar; then in 2018, it became the Custom House Café, a bistro licensed café bar, under new ownership.

The area around the Custom House is known as the Great Quay, which is the most historic part of the Quay. Archaeologists believe that in Saxon times, this area was an oyster fishery and when the Quay area was reclaimed from the sea, a thick layer of millions of oyster shells was discovered.

In medieval times, the area of the Great Quay was surrounded by large stone buildings of which now only the Town Cellars remain (see King Charles and Town Cellars).

The original Custom House was built in 1747, but was destroyed in a fire, which started nearby at the Kings Arms (see Stable) in 1813. It was rebuilt shortly afterwards in the style of the original.

At the front of the building is a replica of a weighing beam, which was used to determine customs duty. There are also two matching flights of stairs that grandiosely sweep up to the entrance in a similar style to the steps of the Guildhall.

The Quay steps near the Custom House were known as the Custom House Steps, as this was a point that ships could berth to declare their taxable goods.

In 1747, the same year the Custom House was built, a dramatic incident took place in which the notorious Hawkhurst smuggling gang from the Sussex–Kent border staged a daring raid to reclaim contraband that had been confiscated by customs officials.

The Custom House Café.

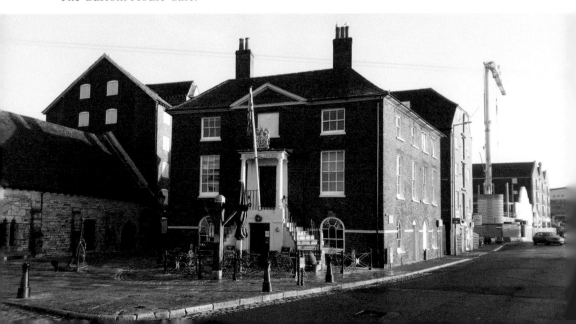

Inside the Custom House Café.

Their vessel, named *The Three Brothers*, which contained a cargo of brandy, rum, tea and coffee, was intercepted by tidewaiters. These were customs officers, who waited in customs sloops on the tide to collect duty on goods brought into a port.

The confiscated consignment was stored at the Custom House, and was guarded by a customs sloop moored alongside. Undeterred, the gang waited until low tide, which had the effect of bringing the sloop's guns below the level of the quayside, thus rendering them useless. The gang tied up the night watchman before breaking in and escaping with the goods on horseback. Although no one was injured in the original attack, a potential informer was later murdered on the roadside.

At least half of the gang were subsequently captured and hanged.

Although this was the most audacious attack, the Custom House has witnessed many other raids and attacks, which were frequently of a violent nature.

Much of the alcohol seized from smugglers by customs at the Custom House was often sold to merchants or landlords of public houses. On some occasions, it was even bought back by the smugglers as they often still needed to fulfill their order.

On the sea-facing wall of the Custom House Café is a plaque commemorating the involvement of Poole Quay on D-Day (see D-Day).

Smuggling in Poole

By the late seventeenth century, piracy was abating, but a new unlawful trade of smuggling was becoming widespread, and in the sixteenth, seventeenth, eighteenth and nineteenth centuries, peaking between 1770 and 1815, Poole's coastline abounded with smugglers, mainly due to the ideal prerequisites of a long shoreline and numerous inlets.

There were mitigating factors to these activities, as it was a time when high taxes were sought to finance wars. Also the imposition of duty on imported goods significantly raised prices beyond the pocket of many.

Landlords would frequently use barrels of wine, Madeira, sherry and port that had been stamped as having duty paid and then refill them with smuggled liquor.

In 1804, smugglers were so prolific in Poole that customs officials estimated that 120,000 gallons of liquor was coming in on which duty had not been paid.

By the 1850s the effect of the return of peace after the Napoleonic Wars, along with more efficient customs and tax reductions, all but destroyed the practice. Another factor in the decline of smuggling was the introduction of the coastguard in the 1820s, which increased the risk of being caught.

Notorious Poole Smugglers
Bennett, Robert
Robert Bennett lived at the George Inn and used the premises to store tobacco, which he would claim was sea damaged in order to avoid paying tax on it. The George Inn is now Scaplens Court (see George Inn old/Scaplens Court).

Carter, John
John Carter was the head of a violent smuggling gang. He led a double life as a legitimate merchant who owned many businesses, and unbelievably was Mayor of Poole from 1676 to 1681, 1699 and 1705. His businesses provided numerous hiding places and outlets for the contraband.

Corrupt Customs Officials
In the late seventeenth century, Poole Customs House was under the command of an alcoholic by the name of Dudley Hopper, who spent most of his working hours inebriated. This enabled one of his officials, Thomas Barney, to frequently take advantage by accepting payment to allow certain goods ashore. Another Poole Customs man was dismissed as he was found to be in league with the Carter gang.

Gulliver, Isaac
Isaac Gulliver (1745–1822) was Dorset's most celebrated and successful smuggler. Although he was actually born in Wiltshire, he lived the majority of his life in Kinson, which was originally in the Borough of Poole, but is now in the Borough of Bournemouth. There used to be a pub in Kinson called Gulliver's Travels.

He was a wanted man after his involvement in a clash with customs officers. He regularly evaded their attention, and on one occasion was secreted out of the Kings Head, hidden inside a barrel, under the very noses of customs officials. On another occasion he eluded customs men by lying motionless in a coffin with his face covered with white powder as he played dead.

He controlled a massive smuggling operation that spread its tentacles across the whole of Dorset and into Devon, Wiltshire and Hampshire.

Having amassed a tidy fortune, he retired from smuggling and was given a king's pardon by George III. He became a wine merchant (although it was believed that a large proportion of his wine was of the smuggled variety), banker and civic leader in Wimborne. He is buried in the vault of Wimborne Minster.

His pistol is in the Russell-Cotes Museum in Bournemouth. It is claimed he never used it, as although he was a powerfully built man, he was considered a gentleman.

There is an area in Poole where Isaac Gulliver plied his trade, which was formerly called Salterns, but was renamed Lilliput. Many believe the name change refers to the well-known book *Gulliver's Travels* by Jonathan Swift, in which Gulliver, a sea captain, travels to a land called Lilliput.

Trotman, Robert

Robert Trotman is buried in Kinson churchyard in the Borough of Bournemouth. He was shot in 1765 during a fierce battle with customs men who found twenty smugglers loading a consignment of tea on the shore between Poole and Bournemouth.

The inscription on the headstone reads:

> Robert Trotman, barbarously murdere'd by the Revenue 1765:
> A little tea one leaf I did not steal.
> For guiltless blood shed. I to God appeal.
> Put tea in one scale, human Blood in t'other.
> And think what tis to slay thy harmless Brother.

D-Day

Poole contributed greatly to the D-Day effort, and was the third largest embarkation point for allied troops during Operation Overlord. The vast majority of the troops were American and were destined for Omaha and Utah landing beaches in Normandy.

A terracotta plaque created in 1994 by Poole Pottery to mark the fiftieth anniversary of D-Day.

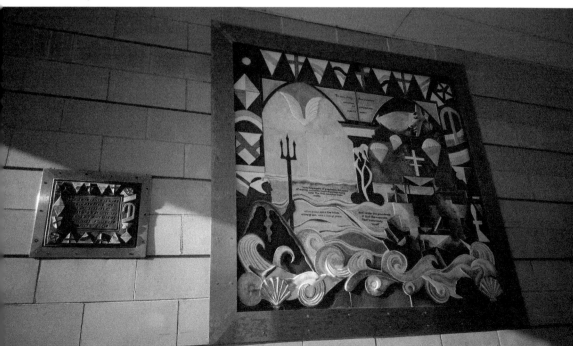

Local shipyards built many of the landing craft, gun boats and launches. J. Bolson & Son of Hamworthy really stepped up to the plate in the hour of need by transforming their small yacht building outfit into an operation that was manufacturing a landing craft per day.

Dorset Yacht Company of Hamworthy were also engaged in building landing craft, while other Poole/Hamworthy firms based around the Quay such as Sydenhams, Newmans, and Burt and Vick were involved in the manufacture of Mulberry Harbour, which was the temporary harbour transported across the channel to serve as a makeshift base from which to launch the assault.

Hamworthy was a training base for troops preparing for D-Day and had a major role in Operation Smash, a rehearsal for the real thing. This involved assaulting beaches at Studland and Shell Bay, both considered very similar to those in Normandy.

On 5 June 1944, the vanguard of 3,000 assault troops left from the Quay. They were followed in subsequent weeks by a total of 22,000 soldiers and 3, 500 vessels.

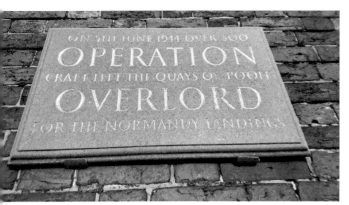

Left: A plaque on the side of the Custom House Café.

Below: A plaque on the Eastern Quay.

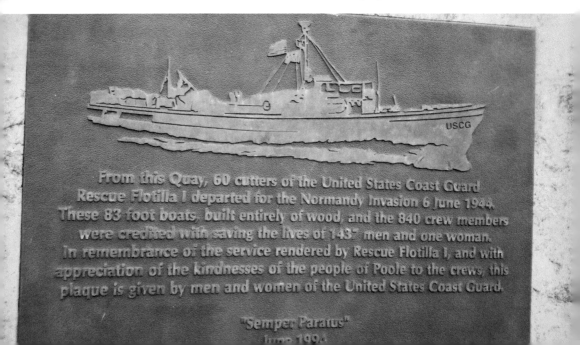

Right: An American flag in St James'
Church which flew on a US Coast Guard
cutter that took part in the D-Day
landings.

Below: A plaque relating to the
American flag.

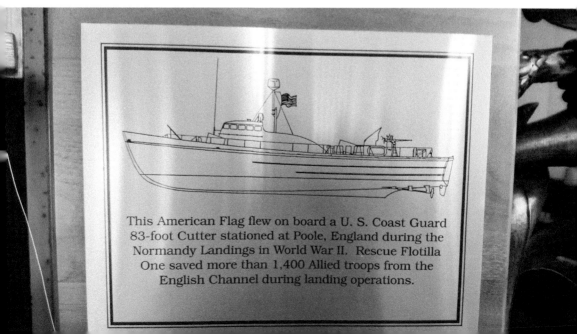

This American Flag flew on board a U. S. Coast Guard
83-foot Cutter stationed at Poole, England during the
Normandy Landings in World War II. Rescue Flotilla
One saved more than 1,400 Allied troops from the
English Channel during landing operations.

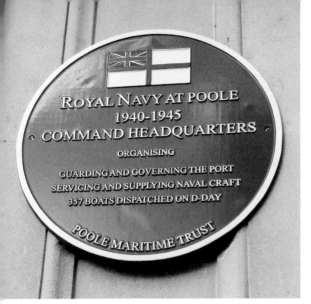

A plaque on the Alcatraz Café, which was the Royal Navy Command Headquarters at Poole from 1940 to 1945.

Poole at War

Poole didn't receive the heavy bombing that the nearby south coast cities of Southampton and Portsmouth endured. However, the Luftwaffe frequently jettisoned unused bombs on the town before returning to Germany.

Many bombs were lured away from Poole by the lighting of fires on Brownsea, which made the island look like a well-lit town from the air at night. Baden-Powell would surely have approved of such subterfuge.

Brownsea Island was also used as a temporary haven for displaced Dutch and Belgium refugees escaping the German occupation of the Low Countries. Three thousand of them arrived in 1940, in small ships, and were temporarily billeted there while they underwent medical checks, before passing on to the mainland. Hopefully they weren't there while the island was diverting the bombs.

Another piece of subterfuge was the use of an underground fuel depot for the civilian and military flying boats of BOAC and RAF Hamworthy (see Salterns's Hotel), at Ham Common in Hamworthy. This nearly backfired when a Luftwaffe bomb set the common on fire. This area is now Rockley Park Haven Holiday Park.

Winston Churchill was made a Freeman of Poole in recognition of his service as the country's wartime leader. He was also related to the Guest family, who were lords of the manor at Canford Magna (see Lord Wimborne).

Drift, The Quay

The Drift is a micro bar and gin house that opened in 2014. It was formerly part of Da Vinci's, the Italian restaurant next door.

The Drift is a unit within an attractive Grade II listed building called Newfoundland House. The building dates back to the eighteenth century when Poole merchants were earning fortunes trading with Newfoundland (see Newfoundland Trade).

The Drift was the winner of the 2016 East Dorset CAMRA pub of the year, and the bar top and tables are made of driftwood in keeping with the name of the establishment.

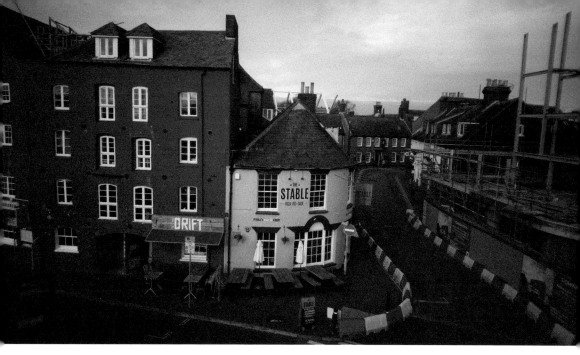

The Drift.

The original owner had a connection with Poole Town Football Club, and sold gallon jugs of ale or lager for fans travelling away to matches at cheaper prices. He also had a beer called Tatnum Glory (The Tatnum is the name of Poole Town's ground), for which a percentage of every pint sold was donated to the football club.

Foundry Arms, Lagland Street

The pub was originally built in 1890, replacing an old beerhouse called the True Blue. In 1955, the Foundry Arms was finally granted a full license, whereas previously it was only a beerhouse and not licensed to sell spirits.

The Foundry Arms.

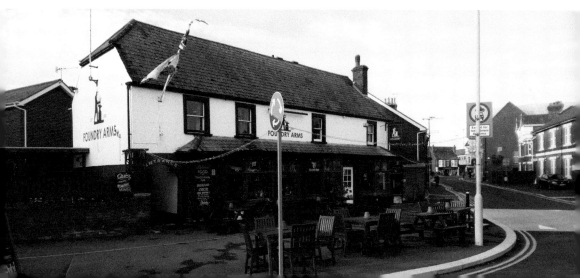

At one time the pub changed its name to the Shoppers Pub in a doomed attempt to entice shoppers in from Sainsbury's over the road, but soon reverted to the Foundry Arms.

The name derives from Stephen Lewin's iron foundry, which was situated opposite the site of the pub and was established in 1866. It was one of many foundries in the town at that time.

Lewin's Foundry
Adjacent to the foundry pub is a block of flats called Lewin Court, which features a tile memorial telling the history of Lewin's Foundry.

The foundry gained a strong reputation for making agricultural machinery, steamboats and train locomotives. In 1872, Steven Lewin was one of the first local employers to dispense with the ten-hour working day, changing it to nine. At this time the foundry was employing 200 people. However, a fire in 1876 destroyed much of the machinery and the foundry had to close.

Steven Lewin was a respected member of the community and was highly regarded by his employees.

The site later became the home of Butler's Brushworks, a brush factory.

George Inn (Old Pub) Now Scaplen's Court, Lower High Street
Scaplen's Court is situated between the King's Head and Poole Museum, on the corner of Lower High Street and Sarum Street, and only came to light in 1923, after the damage from a storm revealed a medieval building hiding underneath a 9-inch layer of brick.

Scaplens Court, which was the George Inn in the seventeenth century.

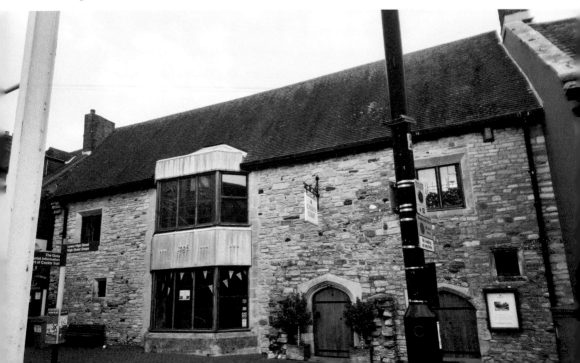

It is a Grade I listed building, built from local Purbeck stone, dating back to the twelfth century. It is believed to have been built as a house for a rich merchant and then developed into a courtyard inn.

It is considered to be Poole's most complete medieval domestic building. Although some historians suggest it was Poole's first guildhall. Merchants would have stayed here, and also pilgrims who sailed from Poole to the shrine of Santiago de Compostela in northern Spain (see Coat of Arms).

In 1598, a rich widow owned the property called Alice Green, who lived with her maid Agnes Beard. Agnes was murdered in the house and it is said that her apron-clad ghost still haunts the building.

Other resident ghostly figures include a bearded man wearing a long black coat. Another figure has been seen wearing a bowler hat, and in fact a ghostly image of this gentleman was apparently caught on CCTV camera in 2008.

In the seventeenth century it was known as the George Inn, and provided lodgings for the Roundheads during the Civil War, as evidenced by some graffiti found on the walls. It is next door to the King's Head, which in those days was called the Plume of Feathers (see Kings Head).

Poole supported the Roundheads, mainly because the merchants were against the ship money tax imposed by Charles I, and were not very happy with the lack of protection from pirates afforded by the Crown (see Newfoundland Trade and Poole Pirates and Privateers).

After the George Inn closed in the eighteenth century, the house was acquired by a prosperous tradesman by the name of John Scaplen.

In 1927, the Society of Poole bought the house and undertook renovations, during which a shilling was found dating back to the reign of Mary I in the sixteenth century.

Coins or tokens dating back to the reign of Charles II have also been found, and local historians believe that the George Inn issued its own beer tokens.

The building was then opened to the public in 1929 and was further restored in 1986. It is now used as an education centre, which is part of Poole Museum. It contains a Victorian schoolroom and kitchen and is open to the public during the month of August.

Guildhall Tavern, Market Street

The Guildhall Tavern in Market Street, along with the Angel and The Crown, are all within a stone's throw from the Guildhall.

An establishment called the Yacht, owned by Poole Brewery was the first licensed premises at this site in 1880. It became the Pensioner's Arms in 1898, before reverting back to the Yacht in 1899.

The Yacht was initially owned by the Habgoods brewery of Wimborne, but in 1915 the John Groves Brewery of Bridport took over.

It became a free house called the Guildhall Tavern in 1971, and today is a gastro pub specialising in seafood.

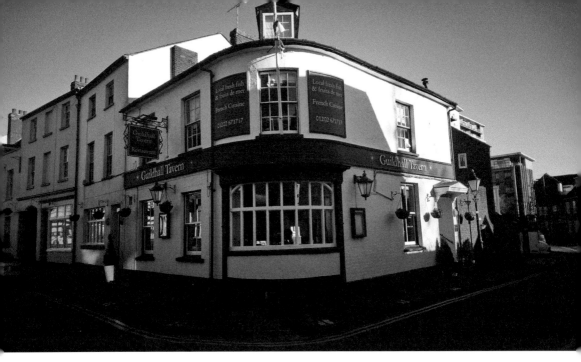

The Guildhall Tavern.

Hotel Du Vin, Thames Street

The Grade II listed building, which is now the Hotel Du Vin, was first commissioned by the successful Newfoundland merchant Isaac Lester in 1776, and then completed by his brother Benjamin.

Isaac and Benjamin Lester were part of an important merchant family that were running Poole's largest Newfoundland fishing and trading outfit, and were accumulating great wealth as a result.

The Port and Starboard Conference Room, which was formerly known as the Lester-Garland Room, houses a marble fireplace, which is adorned, appropriately enough, with two marble cod fillets.

George Garland was a Newfoundland trader who achieved success by developing close trading relationships with the Newfoundland settlements, and also by fostering further close relationships by marrying Benjamin Lester's daughter.

Benjamin Lester was the Member of Parliament for Poole from 1790 to 1796, and later George Garland followed suit, becoming the Member of Parliament for Poole from 1801 to 1806, as well as being Mayor of Poole on two occasions.

George Garland inherited the Lester's Newfoundland business and his son John Bingley Garland also became Mayor of Poole.

In the 1960s the premises became the Mansion House, which was initially licensed as a dining establishment for members only, but then expanded to become a non-member's restaurant and hotel.

The Mansion House was taken over by the national chain Hotel Du Vin in 2007, and is now a hotel, restaurant and bar.

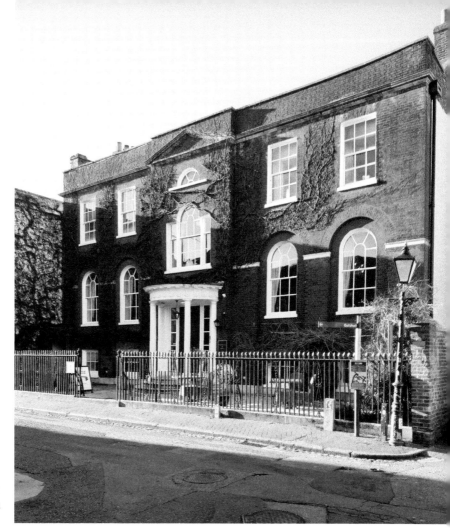

Right: Hotel
Du Vin.

Below: The bar
at the Hotel Du
Vin.

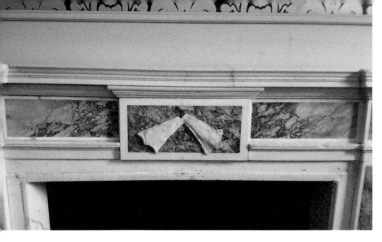

Cod fillets adorning the fireplace of what was the Lester Garland Room when the building was the Mansion House. The room is now called Port and Starboard by Hotel du Vin and is used as a conference room.

Newfoundland Trade

In 1497, John Cabot, the Italian navigator and explorer, sailed west from Bristol on the commission of Henry VII with the objective of finding a passage to Asia, just as Christopher Columbus had tried previously. Unfortunately, Cabot also failed to achieve his actual objective; but like Columbus, he did discover a northern part of the American Continent, which with great originality, he called Newfoundland.

He noted that the seas in this vicinity were so full of cod that they were actually preventing the ship from making headway. Word of this spread throughout the West Country and was paid particular heed to in Poole.

This heralded a golden age for Poole, as merchants seized the opportunity and became pre-eminent in the business of catching cod, and then exchanging the cod for other commodities.

Every spring, hundreds of merchants from Poole sailed across the Atlantic to the cod-rich Grand Banks of Newfoundland. They also took with them goods and commodities that could be exchanged for furs, seal skins and cranberries.

They took much of the cod to Mediterranean countries and the West Indies. In the Mediterranean they traded cod for almonds, figs, olive oil, salt, lemons and wine, whereas in the West Indies the cod was used to feed the slaves on the sugar plantations and traded for molasses and rum. They returned to Poole in the autumn with these goods, along with the cod, furs, seal skins and cranberries.

The Newfoundland trade really started to take off in the seventeenth century, but was at its absolute zenith in the late eighteenth century. At this time thousands of people from Poole and Newfoundland were employed in the triangular trade, as it became known, and by 1790, 230 ships and 1,500 seamen were sailing to Newfoundland every spring.

The merchants grew rich, and as a spin-off, Poole as a town also became wealthy, as local businesses and tradesmen really began to focus on the trade.

Many Poole fishermen stayed in Newfoundland for the winter, which in turn, further generated the economy of Poole, as the food, clothing, fishing equipment, ropes, sails and leather were all being produced in Poole.

In the nineteenth century, the Napoleonic Wars, which began in 1803, boosted trade, as Britain and Spain were allied against the French and had a trade agreement. There was also a blockade of the Danish fishing fleet, meaning that British vessels had a monopoly on the sale of cod to Spain.

Right: Columns in St James' Church constructed from Newfoundland pine. The Newfoundland flag also features.

Below: Memorial to Benjamin Lester in St James' Church.

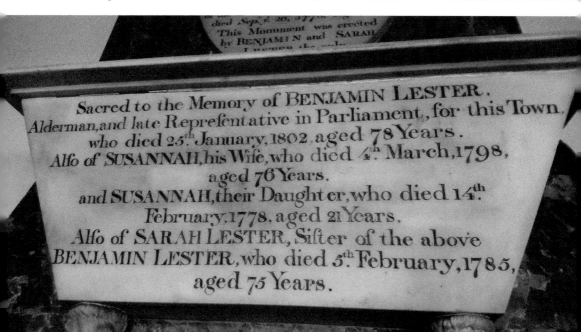

died Sep.ʳ 20, 177.. ..
This Monument was erected
by BENJAMIN and SARAH
..........

Sacred to the Memory of BENJAMIN LESTER,
Alderman, and late Representative in Parliament, for this Town,
who died 25ᵗʰ January, 1802, aged 78 Years.
Alſo of SUSANNAH, his Wife, who died 4ᵗʰ March, 1798,
aged 76 Years.
and SUSANNAH, their Daughter, who died 14ᵗʰ
February, 1778, aged 21 Years.
Alſo of SARAH LESTER, Siſter of the above
BENJAMIN LESTER, who died 5ᵗʰ February, 1785,
aged 75 Years.

Trade increased further when Wellington was victorious in the Peninsular War, opening up the markets of Portugal and Italy.

The Poole merchants even managed to trade with France, despite Britain being at war with them. They achieved this by using a similar triangular trading system involving Poole, the Channel Islands and France. The Channel Islands were still trading with France, whereas British vessels were not allowed to.

The Poole merchants supplied grain, cloth and horses to the Channel Islands and returned to Poole with goods originally from France such as wine, cream and salt.

The wealth of the Newfoundland merchants brought them power, and they wielded a lot of influence in Poole, taking up positions of eminence such as mayor, or as members of Parliament. They also had huge influence with the government in Newfoundland.

In 1815, and the ending of the Napoleonic Wars, the bottom dropped out of the salted cod market, and the Newfoundland trade ceased as many traders went bankrupt.

During the Napoleonic Wars there had been a great demand for fish in Mediterranean countries, as there was a shortage of other commodities. However, in peacetime, these commodities were freely available, meaning there was less demand for fish. Also, their own fishing fleets could now safely put to sea. Plus, fleets from America also started to get in on the action, increasing competition in what was a shrinking market, with the price of cod falling.

There was a brief renaissance of the trade in the early 1820s, but by 1828 only ten British ships were still plying the old triangular route and by 1860 the Newfoundland trade had ceased altogether.

Many sailors from Poole elected to stay in Newfoundland rather than return to an uncertain future. Many stayed simply because they couldn't afford the fare for the passage home. Those that stayed in Newfoundland switched to the seal fur trade or the timber trade. Others returned to Poole and turned their hand to oyster fishing or transporting coal.

The legacy of the wealth generated by the Newfoundland trade can be seen in the fine well-preserved Georgian mansions around St James' Church, Market Street and Thames Street, in the heart of the Old Town. A conservation area has been established here to preserve these fine old buildings for posterity.

Today, it is said that a third of Newfoundlanders can trace their ancestry back to Poole, and the heritage of the Newfoundland trade lives on in many Poole street names; for instance, Cabot Lane, Garland Road, Jolliffe Road, Newfoundland Drive and Labrador Drive. Poole's cultural links with Newfoundland have been re-cemented in recent years with societies from both sides of the pond making exchange visits.

Labradors

Some of the sailors found a very useful and companionable breed of dog while they were in Newfoundland. They were called St John's Dogs or Lesser Newfoundlands. They were ideal for working hard in the freezing weather, retrieving fish from the cold water and helping to haul in the fishing lines. The dogs had an insatiable appetite for work and were highly cooperative.

Other experts believe that when the traders arrived in Newfoundland, there were no dogs there at all, and the dogs that subsequently became known as Labradors were the result of selective breeding of the dogs that were taken across by the Poole seamen.

The sailors often brought the dogs back on the cod ships, and they provided a popular form of transport in Poole, as passengers and equipment were pulled along in dog carts, as was the way in Newfoundland.

In the 1800s, the 2nd Earl of Malmesbury, James Harris, had heard of their qualities and became interested in them as retrievers for hunting. He found them excellent and began calling them Labradors.

At around the same time, Walter Scott, 5th Duke of Buccleuch, also established kennels of St John's Dogs. The Earl of Malmesbury got to hear of this and presented the duke with two male St John's Dogs as a gift. The earl mated them, and by 1903, Labradors were recognised by the English Kennel Club.

There has been a growing campaign locally for Poole Council to commission a statue of a Labrador on the Quay to celebrate the town's connection with the breed, but so far this has been to no avail.

Poole Pirates and Privateers

The Newfoundland merchants probably earned their vast wealth, as sailing to and from Newfoundland would have certainly been no picnic.

They had to contend with the French Navy at a time of hostilities with France, but a greater problem in the earlier days of Newfoundland trading was having to run the gauntlet of French and Spanish pirates, as well as those from North Africa. However, Poole was not whiter than white in this respect, as it certainly had its fair share of homegrown pirates, who also ambushed the Newfoundland traders.

The Newfoundland merchants appealed to the Crown to offer protection, but their appeals fell on deaf ears. This is one reason why Poole supported the Parliamentarians during the English Civil War, whereas most neighbouring areas supported the Royalists.

A privateer was the owner of a private warship that was authorised by the government to attack ships from countries that England were at war with. They were also authorised to take them as prizes and sell off the ship and the cargo, a percentage of which went to the Crown.

Privateers were an accepted part of naval warfare in the seventeenth, eighteenth and nineteenth centuries, as it was a way of mobilising ships to cause maximum disruption to the enemy. However, the boundaries between privateers and piracy were often blurred, as the reality was that privateers were often pirates who took advantage of wars to carry out legalised piracy.

Between 1626 and 1629, at least twelve Poole-based pirates were given 'letters of marque', permitting them to become privateers, specifically to encourage them to attack French and Spanish ships at the time of the Anglo-French War.

By the end of the nineteenth century, the practice of privateering had fallen out of favour due to the chaos it caused and because it encouraged piracy.

Poole Pirates are still in action today, but fortunately only as a motorcycle speedway team, who are regarded as one of the nation's most successful teams.

Notorious Poole Pirates

Broom, John
A Poole-based privateer/pirate who, on one occasion, brought in a vessel bound from Nantes to Dunkirk laden with brandy, silk, coffee and other goods.

Canaway, Thomas
In 1408, Thomas Canaway was among the pirates suspected of capturing a large number of ships from Brittany, and a warrant was issued for his arrest, despite him being the Mayor of Poole at the time.

Heynes, Stephen
In 1583, the Admiralty sent armed ships to purge the pirates of Studland Bay. They rounded up nine pirate captains who were subsequently hanged, but Stephen Heynes managed to avoid capture.

He once captured a ship from Dieppe named the *Endurance* and brought it into Studland. Its cargo included parrots and macaws, which of course made him very popular with his fellow pirates. He also captured vessels from Scotland and Plymouth.

Paye, Harry
Harry Paye was Poole's most notorious and prolific pirate, and is so indelibly associated with Poole that he even has a geographical feature named after him: 'Old Harry', a chalk stack standing in the sea at Handfast Point on the Isle of Purbeck.

He terrorized the Spanish and French coastline in the late fourteenth and early fifteenth centuries, acting in typical pirate fashion, setting towns ablaze, stealing ships and taking hostages for ransom. He gained wealth and infamy, as well as the discreet endorsement of Henry IV as England were at war with France at this time.

Ironically the reason he was so often on the Spanish coast was that he was transporting pilgrims to Gallicia in northern Spain, (see Coat of Arms) in his other role as a sea captain. However, when he arrived in Spain, worship was usually the last thing on his mind, and it would be hard to find a more unlikely pilgrim as he set about ransacking the place.

Old Harry.

On one occasion he so incensed the Spanish by stealing a valuable and very holy gold crucifix from the Church of Santa Maria in Finisterra that, in 1405, the Spanish, under the command of Don Perro Nino, invaded Poole in a revenge attack, setting the area around the Great Quay on fire. They were unable to find 'Arripay', as they called him, as he was away at sea. However, they did succeed in killing his brother in a pitched battle.

After having initially been taken by surprise in the dawn raid, Poole's seasoned longbowmen started to get their act together and began to find their range, exacting a heavy toll of dead and wounded from the Spanish as they were driven back to their ships. Archery was frequently practiced in England at this time, between the battles of Crécy and Agincourt, and in fact, football was banned for a period to ensure that people did practice.

On another occasion, in 1407, Harry sailed into town with 120 captured vessels laden with iron, salt, oil and wine. Apparently, the people of Poole declared the occasion an unofficial public holiday as they proceeded to tuck into the wine.

He died in 1419 and is buried at Faversham in Kent. Poole celebrates his dubious legacy with a Harry Paye Fun Day every June, usually around the 15th. It involves, among other things, a parade of pirates along the Quay.

Piers, John
John Piers was actually a notorious Cornish pirate in the late sixteenth century. He was based in Padstow, but he marauded around the coastline from the Bristol Channel to the Isle of Wight.

In 1581, his mother was accused of being a witch, and in the same year Piers was caught bringing a large haul ashore at Studland Bay. He was arrested, but bribed the jailer of Dorchester jail to escape, before being recaptured and subsequently hanged in 1582.

Meanwhile his mother was acquitted of her own conviction, and is said to have hidden her son's remaining loot in the cliffs at Harlyn Bay, Cornwall.

Pirates of Studland Bay
Pirates in Studland Bay preyed upon shipping using Poole Harbour, and many of the innkeepers were in league with them. The merchants of Poole implored the government to help, and eventually there was a purge in 1583, which resulted in numerous hangings. However, to the dismay of the Newfoundland traders, these setbacks didn't stop the pirates continuing to plunder their ships.

Jolly Sailor, The Quay
The Jolly Sailor first became an alehouse in approximately 1789. It was a rough and ready seaman's pub.

It was rebuilt around 1890 and converted into the building we see on the Quay today. Like the Poole Arms (see Poole Arms), its tiled frontage came from Carters, the predecessors of Poole Pottery, and was added around 1914.

In 1908, Harry Davis became the landlord. He frequently had to use his swimming and life-saving skills to save drunks, who fell into the Quay. He was the head of the Davis dynasty that ran the Jolly Sailor for seventy years.

In the 1920s, a regular patron of the pub was a certain Thomas Edward (T. E.) Lawrence, or Lawrence of Arabia as he was better known.

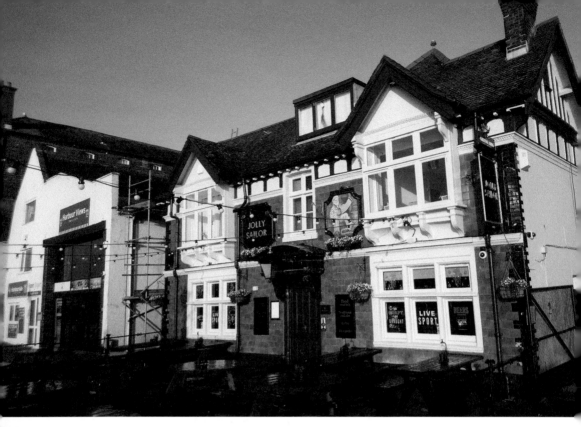

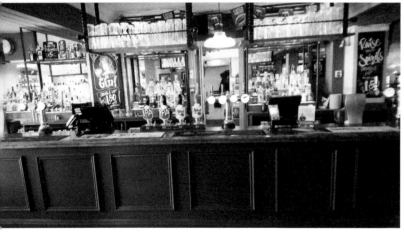

Above: The Jolly Sailor.

Left: The bar of the Jolly Sailor.

The Jolly Sailor and the Lord Nelson are next door neighbours, and in front of both of them a solitary figure looks wistfully across the water to Brownsea Island. The bronze sculpture is Lord Baden-Powell, the founder of the Scout Movement.

Baden-Powell and the Scouting Movement

Baden-Powell learnt his scouting/tracking skills, while serving in the army, by observing tribesmen from around the world.

In 1899, he was posted to the Boer War in South Africa and was based in the town of Mafeking, which was under siege from the Boers. The British were outnumbered

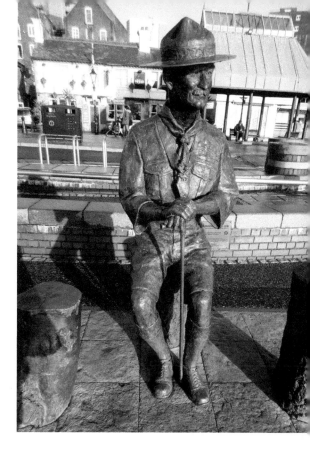

Lord Baden-Powell sculpture by David A. Annan. The plaque reads:

Robert Baden-Powell OM.
1st Baron of Gilwell and Freeman of
 the Borough of Poole
Founder of the Scout Movement.
Poole – Where it all began.

nine to one and he had to use all his skills and resourcefulness to ensure that the town held out until it was relieved. One of the measures he took was to issue small boys with bicycles to act as messengers. He came to value their efficiency and cheerfulness.

In 1904, Baden-Powell attended the twenty-first celebrations of the Boys Brigade and was asked to devise a scheme for giving greater variety in their training. The programme he devised was called Scouting for Boys, which the Boys Brigade only partially adopted. However, realising he was on to something, he contacted a friend who owned Brownsea Island, Charles Van Rault, and initiated the first scout camp.

Baden-Powell wanted to discover what kind of boy would be interested in his scheme, so he invited pupils from public schools and those from working-class families, and also included both city and country dwellers.

Twenty-one boys, including three from Poole and seven from Bournemouth, were at Brownsea on 31 July 1907. They were divided into four patrols and spent their days learning and practicing the skills of scouting, campcraft, cooking, observation, woodcraft, life-saving, hiking, stalking, boating, etc., before retiring for camp fires in the evening. The camp was a great success and was the catalyst for the scouting movement, which then, as today, had appeal for those of all backgrounds.

A stone on the island at the site of the first campsite commemorates the event, and fifty acres are set aside for use by the scouts for camping and scout-related activities. Today, there are 16 million scouts in 150 countries.

The Girl Guides were formed in 1910 by Baden-Powell's sister Agnes Baden-Powell, and she also took the Guides to Brownsea for their first camp.

The centenary of scouting was celebrated on Brownsea in 2007, as scouts from all over the world came together for a jamboree. The Baden-Powell Outdoor Centre and Museum was also opened at this event.

Poole has another association with Baden-Powell as his wife, Olave Soames, was from Lilliput. They were married in St Peter's Church, Parkstone, on 31 October 1912.

Baden-Powell was made a Freeman of Poole in 1929.

Notorious Ladies of the Night

In the seventeenth and eighteenth centuries the ladies of the night were frequently hauled before the courts, where their punishments would include such delights as a day in the stocks, or being ducked on the ducking stool. However, by the early nineteenth century as the port expanded, prostitution was flourishing even more.

Later in the early twentieth century, Black Bess and Cockle Kate were two foul-mouthed prostitutes who, in spite of being banned from every pub in Poole, still plied their trade with alacrity. They were popular with sailors, fishermen and dockers alike, despite their tendency to pick their clients' pockets.

Black Bess was said to be slim, dark and attractive, whereas Cockle Kate, who, as her name implied, was also a hawker of cockles and whelks, was somewhat overweight, and used vocabulary that would strip paint at a hundred yards.

King Charles, Thames Street

The King Charles, which first became an alehouse in 1770, is the third oldest pub in Poole after the Antelope and the Kings Head. However, it has the distinction of having the oldest building, as a section of the pub, known as the Kings Hall, dates back to 1350.

Kings Hall was originally part of one large building known as the Town Cellars or Wool House (see The Town Cellars or Wool House). The building became divided in the eighteenth century, as it was cut through in order to provide a thoroughfare for fish and other commodities to roll through on carts bound for markets in other Dorset towns and London. This became known as Thames Street due to its London connection, and provided an access route from the Quay to the High Street.

The main section of the pub dates back to Tudor times including much of the brickwork and oriel paneling, while some of it is from the later Jacobean period. The older Kings Hall section, which the current landlord refers to as the haunted house, retains the original roof beams and fireplace.

The name changed to the King Charles in the early 1900s in recognition of the exiled French king, Charles X, landing at Hamworthy in 1830. As we have already seen, his family were put up at The Antelope (see The Antelope) while he sailed further along the coast to stay at Lulworth Castle.

The King Charles is believed by many to be the most haunted pub in Dorset, although other Poole pub landlords would not necessarily agree.

One particularly sad story relates to a former landlady and sailor who fell in love and had agreed to marry when he returned from the sea. On the day he was due back, she waited anxiously while looking despondently out to sea, fearing that he had perished in

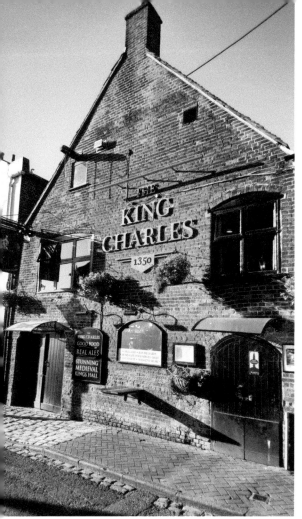

Above left: The Kings Hall, the oldest part of the King Charles, and the oldest pub building in Poole.

Above right: The King Charles pub sign.

the terrible storm that was pounding the harbour and surrounding area that day. Believing the worst when he failed to arrive, she slung a rope over a beam and hanged herself.

The following day, the sailor did return and found the limp body of his intended hanging from the beam. He cut her down, but then in a fit of despair turned the knife on himself, stabbing himself through the heart.

The haunting takes the form of bottles and glasses smashing for no reason, heavy footsteps being heard on the stairs in the middle of the night, doors slamming, and a shadowy figure has been seen dressed in black looking out to sea. Also, visitors have been nudged or tapped, only to find no one there. Some even say they've heard the faint cries of a female voice saying, 'help me, help me'.

Other spirits who are said to be at large in the pub are a laughing fisherman and a ghost of a little girl.

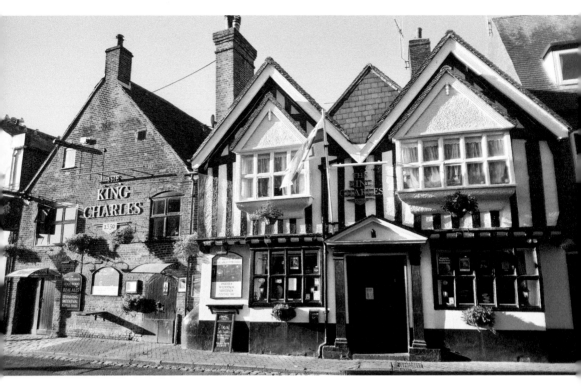

The King Charles showing the Tudor part and the Kings Hall.

The bar of the King Charles.

Right: Interior of the Kings Hall.

Below: The window through which the former landlady kept a constant vigil, looking out to sea in search of her sweetheart. See the table and chairs set out for the ghost's benefit on the upper landing.

The Town Cellars or Wool House

Poole prospered during the twelfth century due to trade with Bordeaux in France, which at the time belonged to the English Crown. This allowed Poole to overhaul Wareham as the premier port and major town in the area and become Dorset's port of staple, which meant it was licensed to import and export staple commodities, mainly wool and leather produced in the outlying areas of rural Dorset.

The building that was used to store those commodities was the Town Cellars/Wool House, which was built in 1350 and stands at the junction of Thames Street and the Quay, adjacent to the Custom House. It is considered to be one of the most important surviving medieval port buildings in northern Europe and the finest surviving example of a wool house in England. It was originally a much larger building, but was divided into two in the 1780s to allow access to the High Street, and thus the main route inland from the Quay (see King Charles).

It is part of this original building that is now part of the King Charles pub. The other, larger section now hosts the Local History Centre, which is part of Poole Museum and is just behind the Custom House.

The building we see today is a fifteenth-century structure, but this overlies an even older structure dating back to 1350.

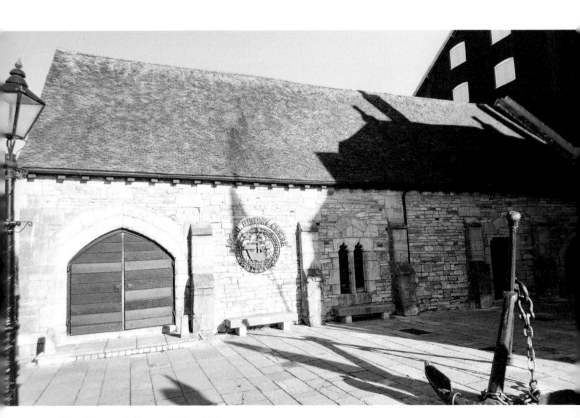

The Town Cellars or Wool House.

The view from the quayside aspect showing Thames Street cutting between the Local History Centre and the Kings Hall part of the King Charles. In medieval times these buildings were one building known as the Wool House or Town Cellars, before Thames Street was cut through them. To the right as you look at the picture is the Custom House Café and to the left is the Harbour Office.

Poole Gaol

Directly opposite the entrance of the King Charles is the old Poole Gaol, which backs on to the Poole Tourist Information Office and Museum (the Poole Tourist Office and Museum is part of the fragmented Wool House). It is situated in an alleyway called Sarum Street.

The date 1820 is carved on a stone lintel above the door and there are iron bars on the windows. It also has an iron ceiling.

Poole Gaol, which is joined onto the back of the Wool House. Also, it is possible to see how the Wool House would have joined to the Kings Hall part of the King Charles before Thames Street was cut through it.

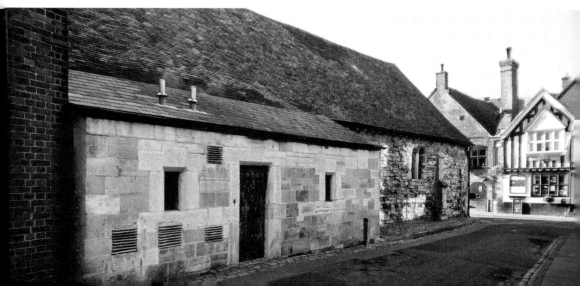

The Harbour Office

At the junction of Thames Street and the Quay, adjoining the Kings Hall part of the King Charles and fronting on to the Quay opposite the entrance of the Custom House Café, is the Harbour Office. It was built in 1727 as a reading room for ships' captains and town merchants, and is now used by the Coastguard.

On the front of the building facing the Quay there is a sundial that was dedicated to S. Weston, Mayor of Poole, in 1814. On a side wall is a relief stone carving of Benjamin Skutt, Mayor of Poole on three occasions – 1717, 1727 and 1742.

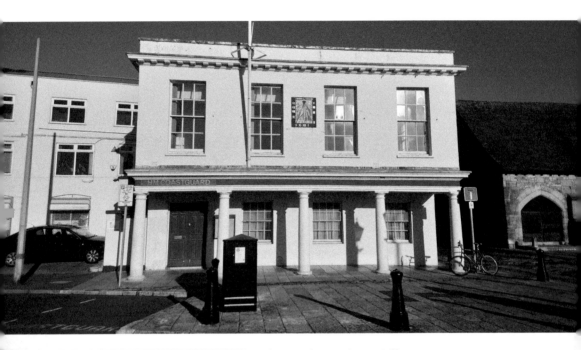

Above: The Harbour Office.

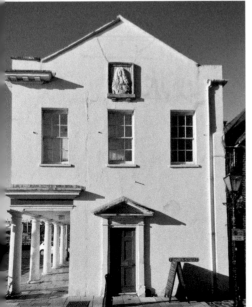

Left: A side wall of the Harbour Office featuring a relief stone carving of Benjamin Skutt.

Kings Head, Lower High Street

A pub called the Plume of Feathers, which can be traced back to 1678, was originally at the site of the Kings Head, making the Kings Head the second oldest pub in Poole still in operation after The Antelope. However, some historians believe there is evidence to show that the Plume of Feathers, which may have been called the Feathers back then, predates the Spanish invasion of Don Perro Nino in 1405 (See Notorious Poole Pirates. Paye, Harry), which would then make the Kings Head, the oldest pub in Poole in continual usage.

The character of the inside of the building has changed greatly over the years, and although many of the original medieval features have been lost, it still manages to retain the feeling of an old pub.

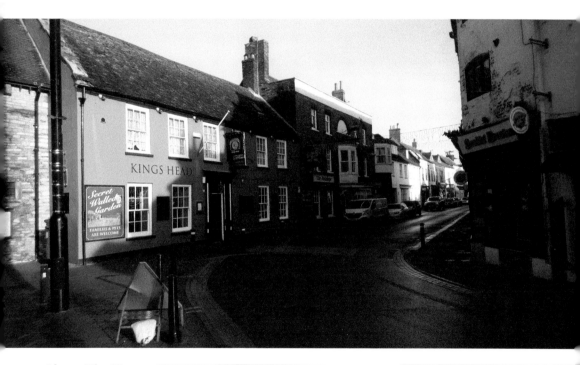

Above: The Kings Head, with the Antelope on one side and Scaplen's Court (formerly The George Inn) on the other.

Right: Inside the Kings Head.

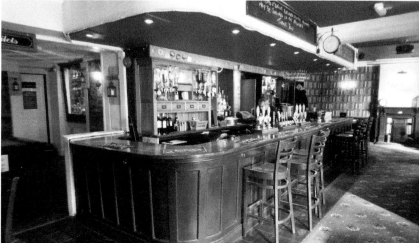

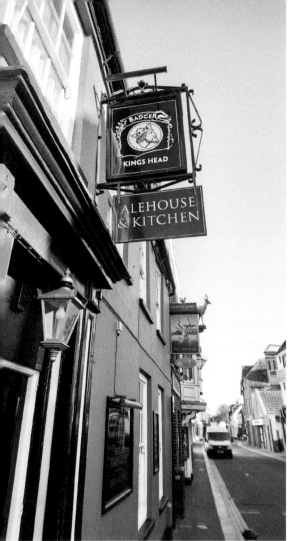

Above left: The Kings Head pub sign.

Above right: One of the smugglers tunnels from the Kings Head can be found under the fruit machine.

Below: The Castle on Brownsea Island was originally commissioned by Henry VIII to defend the strategic position of the harbour entrance. The castle that exists on the island today still retains some of the original stonework.

The pub sign depicts Henry VIII, who is reputed to have stayed at the Plume of Feathers. He used it as a base to check the progress of a castle he was having built to defend the strategic position of the harbour entrance at Brownsea Island. The castle that exists on the island today still retains some of the original stonework.

The pub was known as a notorious smugglers' haunt and smugglers' passageways were found during restoration work. It was known that the Carter Gang (see Smugglers) hid their goods in this pub. One of the tunnels leads to the Quay and another leads to St James' Close near the church.

In 1877, Hall and Woodhouse Brewery of Blandford purchased the pub and they still own it today.

The Lord Nelson, The Quay

The Lord Nelson is situated next door to the Jolly Sailor, and in the summer drinkers from both pubs would find themselves standing among each other, as they also would further along the Quay at the Poole Arms and Portsmouth Hoy. Nowadays, everyone is supposed to stay within their designated area and there are low metal fences surrounding the outside drinking areas of the respective pubs.

The site of the pub was originally an allotment and turf house, and when it first opened as a pub in 1764, it was called the Blue Boar (see Blue Boar), which was the name of the alleyway running alongside it.

In 1810, like a lot of pubs in Britain at the time, the name was changed to the Lord Nelson in recognition of Nelson's famous victory at Trafalgar in 1805. The triumph caused great celebration, but was tinged with sadness due to Nelson's death. He was held in such high regard that he was only the second commoner to be given a state funeral after Sir Isaac Newton.

The Lord Nelson.

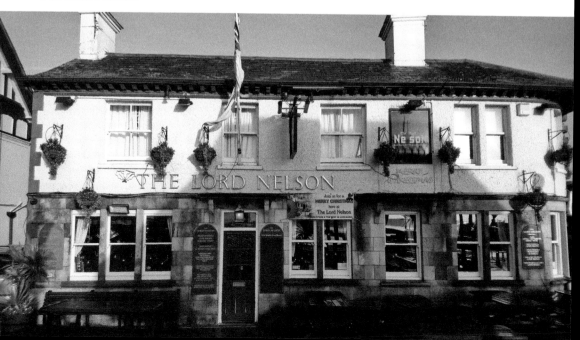

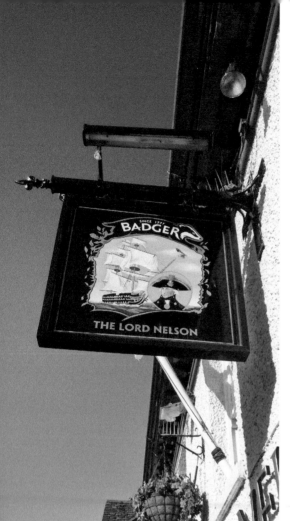

Above left: The Lord Nelson pub sign.

Above right: A plaque dedicated to regular patron of the Nelson: the artist Augustus John.

An appropriate change of name, one might say, as many folk drinking in these quayside pubs were instrumental in Nelson's victory, although, as they supped their ale, they wouldn't have realised that they were going to be involved (see Press Gangs).

The alehouse was originally owned by the Godwin Brothers of Durweston Brewery before they became Hall and Woodhouse of Blandford.

During the 1920s the pub was frequented by the famous and flamboyant artist Augustus John, during a period when he lived in Poole. There is a blue plaque on the front of the Nelson in acknowledgment of this.

The Lord Nelson had an unsavory reputation in the 1950s and '60s, as it was a pub favoured by motorcycle gangs and fights were commonplace. Hall and Woodhouse solved the problem by inserting a new landlord; a tough no-nonsense ex-copper by the name of Jim Kellaway, who soon cleaned the place up.

Inside The Lord Nelson on one side of the bar.

Inside The Lord Nelson on the other side of the bar.

Through the ages, fights have certainly been a feature of the pubs of Poole Quay, but in recent years it's probably better than most town centre drinking environments (see The Quayside at Night). Motorbikes and their owners are still a regular feature, but now they come in peace (see Dream Machine Bike Nights).

Jim Kellaway was also responsible for turning the Nelson into a kind of seafaring museum, as he decked out the place with many artefacts from shipwrecks, which he collected while pursuing his hobby of sub aqua diving in Poole Harbour and elsewhere. However, he took most of these with him when he moved up the road and round the corner to become the licensee of the Blue Boar.

Press Gangs

The alleyways leading from the Quay, behind the pubs and warehouses, were dark and forbidding, and ideal places for press gangs to lurk.

Many a Poole man enjoying a drink on the Quay, in the time of Nelson's navy, would have awoken the next morning with a sore head, as they found themselves on the high seas, sailing off to fight the French as one of the Royal Navy's newest 'volunteers'. The sore head was probably partially due to the alcohol, but in a larger measure due to being coshed on the back of the head. Still, that was the least of their worries; they also had to start coming to terms with a diet of maggot-infested biscuits and regular floggings.

The press gangs were active during the American War of Independence (1775–83), when the French allied themselves with America. Later Britain was drawn into fighting the French Revolutionaries, and then shortly afterwards was involved in the Napoleonic Wars, which, as far as naval engagements were concerned, finished at the Battle of Trafalgar in 1805. Throughout these times the press gangs ensured there were always plenty of men available for active service.

Poole, of course, was known to possess many experienced sailors from the fishing industry and Newfoundland trading, but the town didn't like to crow about this too much, for fear of attracting the attentions of the press gangs. Nevertheless, the press gangs were very much attracted to Poole, and they frequently pressed Poole mariners.

The Quayside at Night

Poole Quay was certainly not a place for the faint-hearted during the eighteenth and nineteenth centuries. It had a reputation for fights, prostitution and heavy drinking, and this continued into the earlier part of the twentieth century, as there were frequent brawls between the rival factions of dockers, gypsies and seamen. Although not exactly the Queensbury rules, there was a certain unwritten code of honour (unlike today), whereby the fights tended to be fair and one on one, without recourse to weapons.

In the years after the Second World War, Royal Marines, bikers and local youths were in the mix, continuing well into the 1990s and beyond to a certain degree.

Dream Machine Bike Night

On Tuesday nights between April and September, motorcycle enthusiasts come from far and wide to Britain's largest weekly bike night. They come to meet fellow enthusiasts for a beer and a chat, and of course to show off their pride and joy.

Dream Machine Bike Night.

The Quay is closed to cars as it becomes a sea of gleaming paintwork and chrome, and a cacophony of throbbing engine noise. There is also a second arena at Harbourside Park, just a bit further along the shore from the Quay, for those frequent occasions when the quay is overly full with bikes.

The event has become popular with bikers, non-biking locals and tourists alike.

Poole Arms, The Quay

The Poole Arms is a Grade II listed building that dates from 1572, making it the oldest pub situated on the Quay.

In 1850, it suffered a serious fire, which resulted in the destruction of the flour company next door.

The building is very distinctive, as it is adorned with green tiles. These were added shortly after the fire and were supplied by Carter's Tiles of Hamworthy, who were the predecessors of the world-renowned Poole Pottery.

High up on the front of the building is a disc of tiles making up the Poole coat of arms, with the town motto underneath (see Coat of Arms).

This is another pub in Poole that is reputed to have more spirits than those dispensed by the optics, with people claiming to have heard strange footsteps, etc.

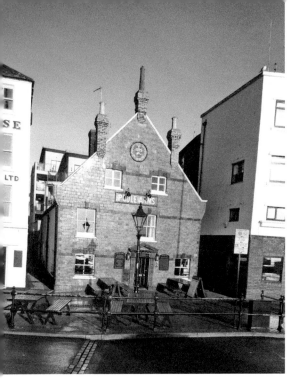

Above left: The Poole Arms.

Above right: The Poole coat of arms on the lifting bridge.

Inside the Poole Arms.

Poole Pottery

Poole has been a centre for pottery manufacture for centuries, as it has easy access to clay and limestone from the Purbeck Hills.

Poole Pottery was originally Carter's Industrial Tile Manufactory, which was founded in 1873 after Jesse Carter took over a struggling ornamental brick and tile company called Walker's Pottery. In 1895 he was able to expand, and also bought out Architectural Pottery. The business flourished to such a degree that many of the tiles on the London Underground were made by Carter's.

In the 1920s, Jesse Carter combined with potters John and Trudy Adams and designers Harold and Pheobie Satbler to become Poole Pottery. They made world-famous pottery from a factory on Poole Quay at the original site founded by Jesse Carter.

They moved from the Quay to another site in Poole in 2001, and then eventually closed in 2006. However, a presence on the Quay is still maintained in the form of a retail outlet at the old premises, which houses the largest selection of Poole Pottery in the world and hosts demonstrations of pottery making for visitors. The rest of the former site is a block of 105 luxury apartments, shops and restaurants called Dolphin Quays.

The name of Poole Pottery still lives on with collectable items still being sold in the likes of Harrods or Tiffany's of New York. However, the pottery is now made in Stoke-on-Trent as part of Stafford Tableware Ltd.

The Carter families became eminent locally, and have been responsible for the establishment of schools in the area; for instance, Herbert Carter School, now called Carter Community School, in Hamworthy.

Poole Pottery still maintains a presence on the Quay.

Poole Coat of Arms

The Poole coat of arms features three scallop shells with a dolphin underneath, underscored by the town motto.

The scallop shell is the symbol of the Santiago pilgrim, which has a great significance to Poole as in the Middle Ages many people embarked from Poole to make pilgrimages to the shrine of Saint James in Santiago de Compostela, Galicia, north-west Spain. The church in the Old Town is also dedicated to St James.

The dolphin signifies the fishing industry, as it is considered to be the marine equivalent of the lion – a king of the seas.

The town motto, which features on the coat of arms, is '*ad morem villae de Poole*', which is Latin for 'according to the custom of the town of Poole'. The motto came into being after Elizabeth I bestowed the Great Charter on Poole in 1568. In effect Poole was granted the status of an independent county within Dorset and was styled the 'County of the Town of Poole'. This allowed Poole to own land and property and exempted merchants from all import and export duties.

The Portsmouth Hoy, The Quay

The Portsmouth Hoy is separated from the Poole Arms by Grace House, which was once the Britannia Inn.

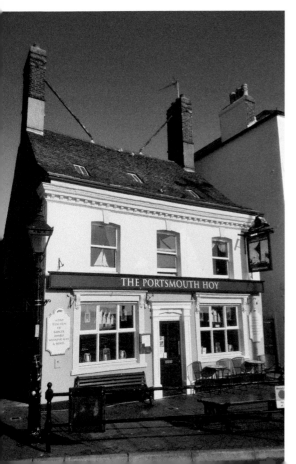

The Portsmouth Hoy.

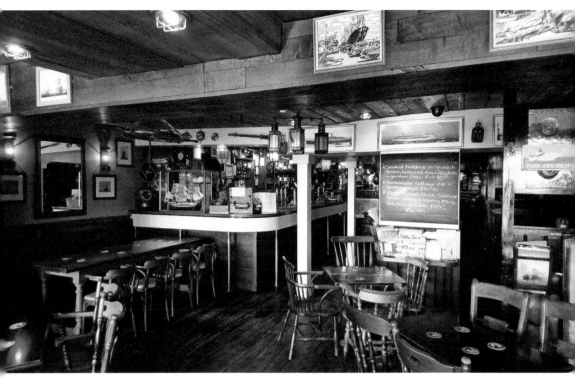

Inside The Portsmouth Hoy, a veritable museum of seafaring memorabilia relating to Poole and Portsmouth.

The Portsmouth Hoy refers to a nineteenth-century coaster, which used to take people daily between Poole and Portsmouth from this section of the Quay. The hoys, as the coasters were known, were considered a more agreeable and quicker method of transport than travelling by coach and horses.

There were also hoys going to Swanage, Wareham, Weymouth and the Channel Islands The nautical term 'Ahoy' comes from passengers hailing these vessels.

Christchurch brewers Daw & Co. first opened the Portsmouth Hoy in 1774 as an alehouse. It was then sold in 1832 to the Poole Brewery, and then eventually to Hall and Woodhouse.

The Portsmouth Hoy narrowly escaped losing its license in 1869 for trading illegally on a Sunday.

Current managers Nigel and Liz have filled the pub with some fascinating seafaring memorabilia of significance to Poole and Portsmouth.

Nigel relates that in a storm the building shakes, which he puts down to the lack of foundations, as the Quay is built upon a bed of oyster shells.

The Quay, The Quay
The Quay was formerly a Grade II listed five-storey warehouse, dating from 1857 and owned by the shipping agents South Coast Lines Ltd. It was converted to The Quay in 1997 and is now a Wetherspoon's pub on two floors.

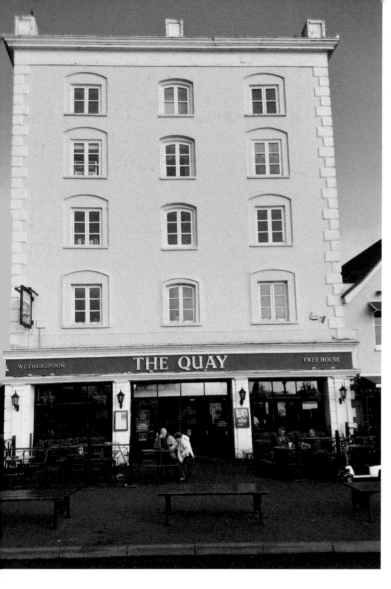

The Quay.

The Quay was featured in the news in 2006 when Prince William was seen drinking there during a break from a sailing course he was undertaking while in the armed forces. It must have been an enjoyable course as he was also spotted in a Bournemouth nightclub later that week.

Rope & Anchor, Sarum Street
The first record of a pub at this site was as the Dolphin in 1813, which subsequently became the Old St Clement in 1865. It then became the Victoria in 1880, which closed in 1890.

Afterwards it reverted to being a private house, and then a café called Aunt Flo's Tea Shop, before becoming a pub called Cranberries @ No. 4 in 1996. A strange name, but remember cranberries were one of the commodities brought back to Poole by the Newfoundland traders, and the address is No. 4 Sarum Street.

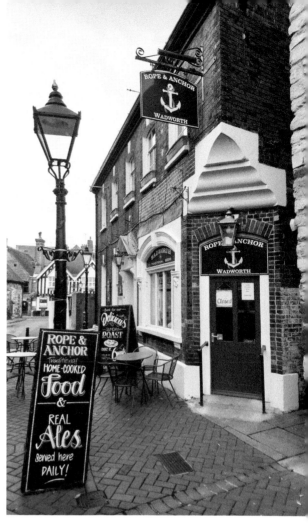

Right: The Rope & Anchor.

Below: The bar of the Rope & Anchor.

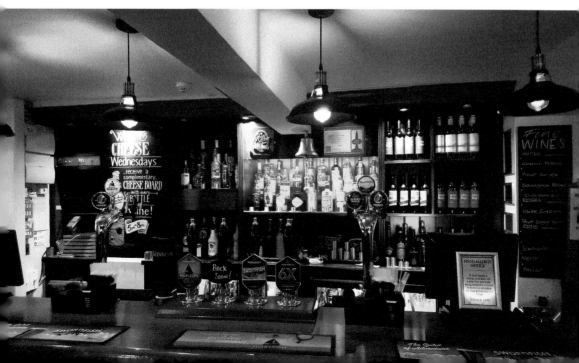

In 2003 a fire virtually destroyed the inside of the building, although firemen managed to save the basic structure.

The building was reopened in 2006 as the Pub With No Name and then sold to a new owner in 2008, who restored the name of Cranberries @ No. 4.

In 2015, the current tenants, James and Daniel, took over, renaming it the Rope & Anchor. They opted for a more traditional nautical theme, getting away from the litany of unusual names. They won an award shortly afterwards from Wadworth's Brewery for Best Newcomers.

The pub is situated next door to Scaplen's Court and opposite the Tourist Information Centre and Museum, in a small alleyway between the Quay and the High Street. It is in a busy area, but slightly tucked away from the main drag of the Quay. The narrow street of Sarum Street has the Kings Head at the High Street end and the King Charles at the other Quay end. In days gone past, this small alleyway accommodated no less than five pubs.

Slug & Lettuce, Lower High Street

Situated at the junction of Lower High Street and Castle Street, the building that is now the Slug & Lettuce was originally a private house built around 1775. It later became a china gift shop and then a furniture shop.

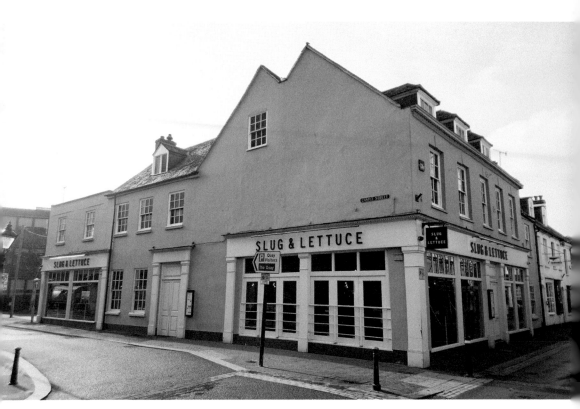

The Slug & Lettuce.

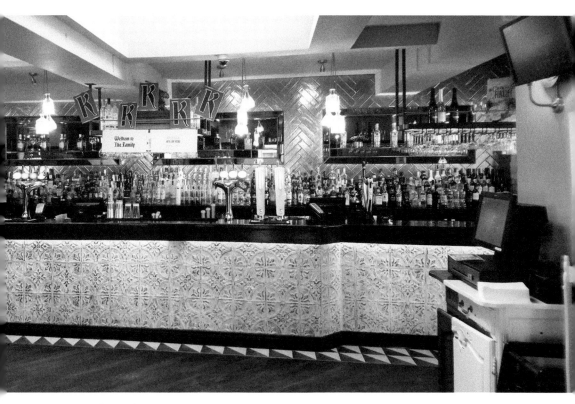

The bar of the Slug & Lettuce.

In 1997 it opened as the Hogshead public house, owned by the nationwide chain the Stonegate Pub Company, who are based in Luton, Bedfordshire.

The pub was refitted in 2007 and renamed the Slug & Lettuce, which is another brand within Stonegate.

Stable, Lower High Street

The Stable is situated at the junction of the Quay and the Lower High Street. Its immediate neighbour on the Quay is the Drift.

The establishment was originally called the King's Arms and was thought to have been in existence before 1697. Records prove that in 1779 it was an alehouse owned by Daw and Blakes of Christchurch, but was purchased by Styrings of Poole in 1832.

The Kings Arms was a mustering point for market boats or hoys that brought people into Poole from Studland and the Purbecks.

In 1813, a serving girl tripped while carrying a lighted candle, causing a fire that badly damaged the building, as well as destroying the Custom House (see Custom House Café). Some say the building is still haunted by the unfortunate girl.

In the 1970s the name changed from the Kings Arms to the Helmsman, which it remained until the late 1990s, before having a series of diverse names: The Water's Edge,

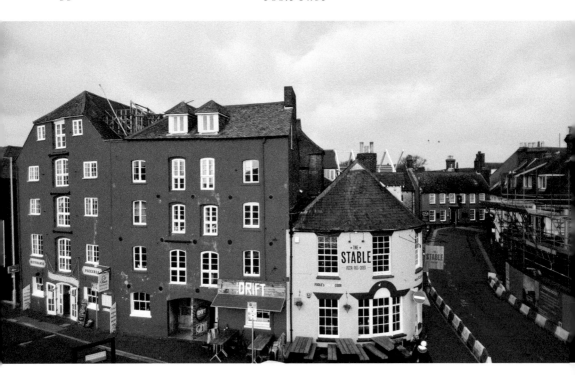

The Stable.

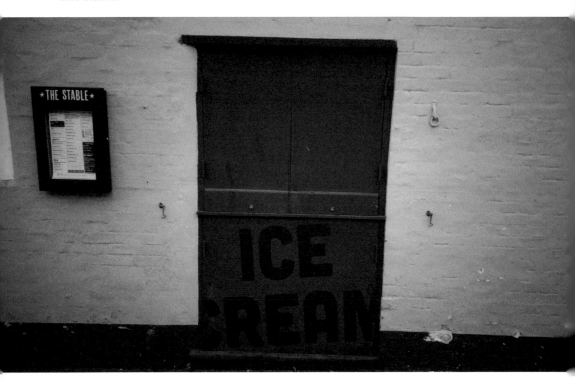

The horse-tethering ring at the Stable.

Hector's House, The Inn on the Quay and the Spotted Cow, before finally becoming the Stable in 2007, or, as it should more correctly be called, 'Stable Pizza Pie and Cider'.

The present building still has the original ring for tethering horses on its outside wall, so the current name is fitting, although the Stable is actually part of a chain of pizza and cider bars, mainly in the south of England.

Tin of Sardines, Lower High Street

Lord Trevor Davis and his son Ben opened the first Tin of Sardines gin bar in 2017 in Durham. It was billed as probably the world's smallest gin bar, and has a capacity of only sixteen people. The format obviously worked, as in 2018 they opened a similar venue in Poole, also called a Tin of Sardines, at the site of a former newsagent's called the Cabin. This establishment has a slightly bigger capacity of twenty seated and twenty standing.

It is situated within a stone's throw of the Quay and is ideally suited for yachties to come aboard. When they do, they will feel right at home, as the interior has the theme of a motor yacht.

As in Durham, they offer a choice of a mere 300 gins and forty mixers from around the world with food to accompany.

Ben and Trevor have quite an empire in Durham, including pubs called the Court Inn and the Old Tom, as well as an outside catering company called the Cheese and Pickle Company, but after years travelling and working as a chef for the rich and famous, Trevor has returned to his native Poole.

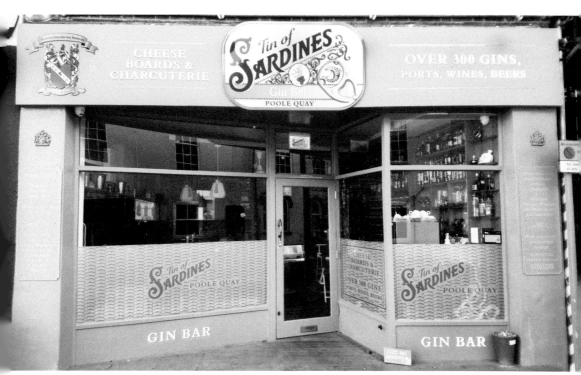

The Tin of Sardines.

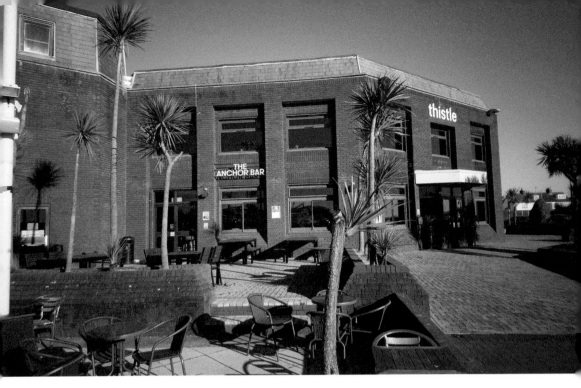

The Thistle.

Thistle Hotel, The Quay

The site, which is close to the Marina and the Fishermen's Dock, on the far eastern aspect of the Quay, was formerly a coal storage yard for Poole Gasworks.

It first opened as licensed premises in the form of the Quay Hotel in 1980, which was built by a local consortium led by Mrs Rachel Allenby, a descendant of the Jolliffe family of Newfoundland merchants (see Drift). It was opened by the Mayor of Poole at the time, Mrs Doris Webster OBE, and Algie Cluff, the North Sea oil pioneer.

The consortium then sold it to Mount Charlotte Hotels, who opened it as the Thistle Hotel in 1983. It is a three-star hotel that is popular with business visitors during the week and is also a popular wedding venue.

The hotel, including the Anchor Bar, was revamped internally in 2012. The Anchor Bar has a terrace overlooking the Quay.

Fishing

The town of Poole was built on fishing, and there is still a sizeable fishing fleet consisting of around a hundred registered boats based at Fishermen's Dock, just opposite the Thistle.

The shallow harbour is a significant breeding ground for mussels, clams, oysters and cockles, so the fishing fleet mainly focuses on shellfish and crustaceans from within the harbour, although many also venture further afield into the English Channel to catch crustaceans or other fish such as mackerel or plaice and other flat fish.

Some of the world's finest oysters are bred in Poole Harbour, and a ready market is found among the numerous hotels and restaurants of this part of the world, as well as in China and Japan.

The Fishing Fleet.

Oysters

It is believed that there was an oyster fishery in Poole Harbour during the mid to late Saxon era, and much of the Quay is built on a bed of oyster shells, which is several feet thick.

Oysters were in great abundance and were consumed in large quantities. However, the seemingly limitless supply eventually dwindled due to overfishing, mainly by seamen formerly employed in the Newfoundland trade.

Upon their return to Poole many took up oyster fishing, but through desperation to make a living, they fished for them out of season. As a result, by 1860, the oysters had been overfished to virtual extinction.

In the twentieth century the local oyster fishing industry was revived, as elsewhere in the country, by the cultivation of Pacific oysters from abroad, which were introduced in the 1960s to replace the dwindling native species.

2

Central Poole

Some of these pubs, namely the Brewhouse and Kitchen, the Butler & Hops and The Queen Mary, are considered old pubs, but technically fall just outside of what is considered to be the Old Town.

Brewhouse, High Street
The Brewhouse was originally a vehicle to provide an outlet for the Poole Brewery, which from 1980 brewed beer on an industrial estate at Sterte near the town centre.

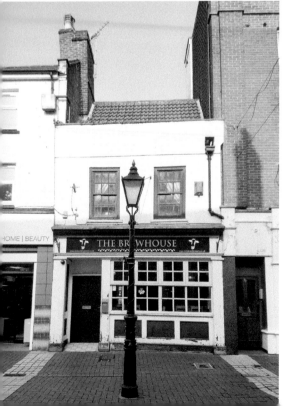

The Brewhouse.

The brewery later purchased a shop in the High Street, which it turned into a pub incorporating a microbrewery. Thus the Brewhouse was opened in 1983.

In 1988, the premises suffered from a fire, which mainly affected the flat above. However, the pub was forced to close while it was rebuilt, finally reopening in 1991.

Brewing continued on the premises until August 2002, when the brewery behind the pub was sold and converted into flats. The Milk Street Brewery of Frome, Somerset, now supplies the beer instead.

Brewhouse and Kitchen, Dear Hay Lane

The premises have been licensed since 1789, but the building is at least 150 year older than that. It was originally known as the Brewers Arms, as it had its own brewery, but by 1800 it was tied to the Dolphin Brewery of Poole, before passing to Marston's and then Whitbread's over the years.

In the 1960s and beyond, the ceiling contained an array of foreign coins, mainly stuck there by Royal Marines based in Poole, who had collected them on their travels.

The pub was believed to be haunted when it was the Brewers Arms by a lady called Mary, who was burned to death in a house nearby. Mary's haunting days are apparently over, as she seems to have only been interested in haunting the pub while it was the Brewers Arms.

The premises became the Rising Sun in the year 2000, and had a period of being a Thai restaurant/pub. It was during this period in 2005 that the pub was nearly destroyed by fire.

Poole firemen arrived at the scene and quickly realised the gravity of the situation. They called for back-up from neighbouring fire stations, and thus prevented the fire from spreading out of control.

The Brewhouse and Kitchen.

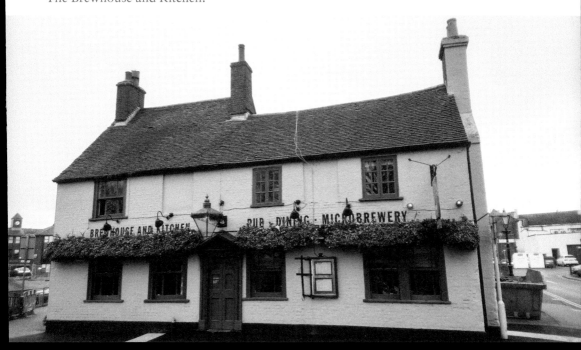

The pub was then shut for a period, but reopened as a gastro pub offering predominantly English food; perhaps they were conscious of the fact that the fire started while they were trying to cook egg fried rice.

The pub then shut again for a time before opening in 2015 as the Brewhouse and Kitchen, a nationwide chain founded by Bournemouth man Kris Gumbrell and his business partner Simon Munn.

The group focuses on rescuing derelict pubs. They brew craft beers on the premises and aim to provide family dining. The chain deliberately does not offer Sky Sports or fruit machines but does offer courses on brewing.

Butler & Hops, High Street

A pub has existed at this site since 1761. Originally, it was an old coaching inn known as the London Tavern and was built by John Butler, hence the current name.

In 1830 some of the exiled French king Charles X's entourage, who couldn't be accommodated at the Antelope, stayed at the London Tavern (see King Charles and the Antelope).

The London Tavern then became the London Hotel. It was in this guise in 1940 that the premises were badly damaged by a German bomb, which destroyed the shop next door, necessitating substantial renovation to the pub.

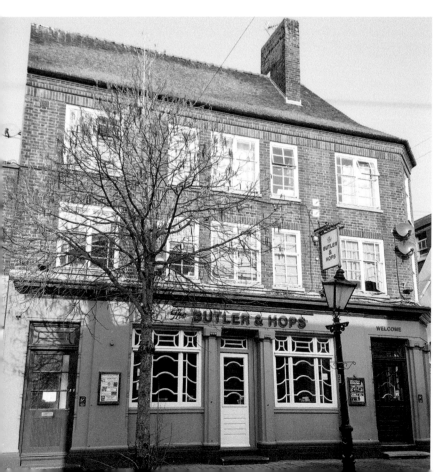

The Butler & Hops.

The bar of the Butler & Hops.

It continued to be called the London Hotel until 1969, when it was internally refitted to become the Old Harry, featuring a picture of Harry Paye, the notorious Poole pirate on the pub sign (see Notorious Poole Pirates).

In 1979, the brewers Eldridge Pope of Dorchester, who owned the Old Harry, swapped a pub in Bath called the Crystal Palace owned by Bass Charrington, so the Old Harry then became owned by Bass Charrington.

The pub was subsequently renamed the Café Mango in 2001, and then became the Globe Café in 2003.

The establishment is now called the Butler & Hops, is owned by Marston's brewery, and features several big screens, making it an ideal venue to catch up on the footie.

Delfino Lounge, Falkland Square

The Defino Lounge opened in 2017 at a site that was formerly a shop. It is opposite the Dolphin Shopping Centre, which explains the name, as Delfino is Italian for Dolphin.

There is a large mural of a dolphin behind the bar, which of course is the symbol of Poole (see Poole Coat of Arms). The site consists of two floors of café/bar area.

It is a Lounge bar, which is a well-established chain on the south coast, all of which feature the word 'lounge' in the title. The company states that 'the lounges are informal, neighborhood food led café/bars open all day everyday where families, friends and locals can come in for a coffee, a drink, or something to eat in a relaxed comfortable environment'.

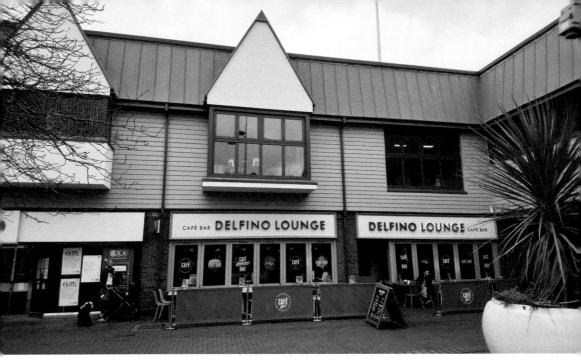

The Delfino Lounge Café Bar.

Dolphin Centre

The Dolphin Centre is Dorset's largest indoor retail complex. It was first opened in 1969 as a two-storey shopping centre on what was called the Ladies Walking Field. It is situated at the northern end of the High Street and was originally called the Arndale Centre.

The complex also included a sports centre (which is sadly no longer there and has been replaced by The Project Climbing Centre), library, bus station and multistorey car park.

The Dolphin Centre. Not all of Poole is a beautiful place.

Poole Arts Centre, Dolphin Swimming Pool and Barclays House (Barclays bank offices) were also built shortly afterwards. Apparently they are all fine examples of late sixties and early seventies architecture, so are listed buildings and can't be pulled down, despite them being square block monstrosities; the type of thing that would give Prince Charles nightmares. They also rather muck up Poole Tourist Board's slogan: 'Poole is a beautiful place'.

The Arndale Centre was hugely popular with children as it featured wooden sculptured animals to climb on.

In 1988 a revamp took place, and the Arndale Centre was renamed the Dolphin Centre, but the wooden animals were retained until 1997.

There are proposals afoot to further refurbish the Dolphin Centre and incorporate a seven-screen multiplex cinema.

George, High Street North

The George was first in existence in 1823 as The George & Antelope, before becoming the George Hotel in 1865. It was then bought by Styrings Brewery as an alehouse, which, in turn, was eventually bought by Eldridge Pope of Dorchester.

A toll house just outside the George Hotel charged coaches to enter the town. The tolls were abolished in 1882, but the toll house remained in situ, and was used as a newspaper stand from 1916 until it was demolished in 1926.

The George Hotel was knocked down in 1927 to be replaced by The George.

From 1919 until the 1960s, the landlord was firstly Mr R. Adams, who was then succeeded by his son Ted.

The George.

The George is just out of the main town centre and attracts a sizeable lunchtime trade of office workers, particularly from Barclays House, the building in the background, which is one of Barclays Bank's Head Offices, and another example of the stunning (stunningly bad) 1960s/70s architecture in this part of Poole.

The pub has a pay and display car park to prevent office workers parking there all day.

Lord Wimborne, Lagland Street

In 2002, The Lord Wimborne, a Wetherspoon's pub, opened at a site that had previously been the town public library.

Lord Wimborne was a local landowner and philanthropist who, in 1887, donated land to be used for the benefit of the townspeople, as a way of recognising Queen Victoria's Golden Jubilee. Alderman John Norton, a timber merchant, suggested a free public library and agreed to meet the cost of building it.

The benevolence of Lord and Lady Wimborne were also responsible for providing Poole Hospital, Poole Grammar School and Poole Park.

The previous library, which was not a free library, was at the Quay end of the High Street, and was provided by the Newfoundland merchant Benjamin Lester in 1830 (see Hotel Du Vin).

Alderman Norton will surely be turning in his grave at the current usage of the library he financed and built as he was a devout teetotaler.

The Lord Wimborne.

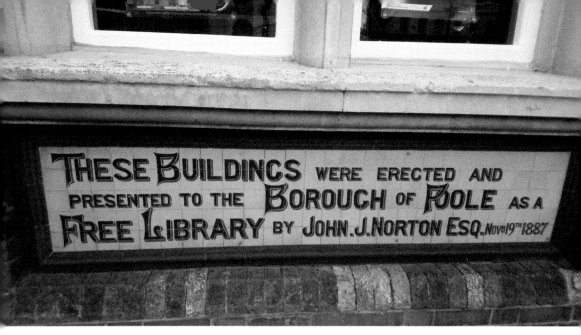

Above: A plaque on The Lord Wimborne.

Right: The Lord Wimborne pub sign.

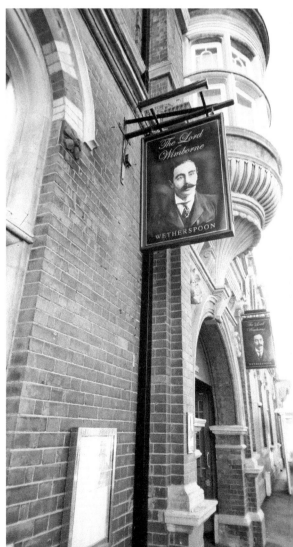

Lord Wimborne (the Man Himself)

Sir John Guest was a Welsh engineer and entrepreneur who had made a fortune from a steelworks in South Wales.

Sir John and Lady Charlotte Guest purchased the Canford Manor estate in 1846 (now Canford School), thus becoming the lord and lady of the manor. They had a son called Ivor Guest.

Ivor married in 1902, and he and his wife, Cornelia, were given the title of the First Lord and Lady Wimborne.

The town greatly benefitted from their alliance as they had a very philanthropic outlook.

They initially opened a small hospice for the poor in West Street; but later Lady Wimborne persuaded her husband to open Cornelia Hospital in Longfleet Road in 1907. This was renamed Poole General Hospital in 1948, and now forms part of Poole Hospital NHS Foundation Trust.

In another great act of benevolence they donated two areas of land to the people of Poole, in the form of Poole Park and Parkstone Park, now called Ashley Cross Green.

Poole Park was opened in 1890 by the Prince of Wales, later to become, Edward VII, who stayed at Canford Manor the night before as a guest of Lord and Lady Wimborne.

In 1963 the park included a zoo, which closed down in 1994. Among the exhibits were some peacocks, whose loud cries were particularly annoying for neighbours, resulting in them being banished to Brownsea Island, where their relations still exist today.

The park became known as the people's park as it could be enjoyed by everyone, and in 2015, celebrated its 125th anniversary. Today the park boasts of facilities for cricket, the park run, windsurfing, sailing, paddle boating, rowing, boating, kayaking, tennis, two children's playgrounds, indoor ice skating, a children's ball pool, crazy golf, bowling green, a miniature railway, model boating, a café and two restaurantst where you can watch ducks swans and geese in both instances, plus anything else you can think of to do on a large expanse of grass such as playing football or enjoying a picnic.

Lord Wimborne was elected Lord Mayor in 1896 in recognition of the great contribution he had made to the town.

The Queen Mary, West Street

The first pub in existence at this site was an alehouse named the Old Inn, which opened in 1819 and was owned by the Dolphin Brewery of Poole. It then had a brief period as the Old Bell, before becoming The Queen Mary.

In 1988, the intervention of over a hundred fire fighters, who dowsed the pub with gallons of water, saved it from being destroyed by a fire that broke out at the British Drug Houses warehouse next door. This was one of the biggest fires in Poole's history, and the intensity of the heat caused nearby traffic lights to melt. A further issue was exploding 45-gallon drums of chemicals, which showered debris over a wide area causing clouds of gas to hang over the town. This resulted in the largest peacetime evacuation in Britain, as up to 5,000 residents were removed to safety overnight.

It is a three-roomed guest house situated slightly out on a limb, but by the same token close to the Quay, Old Town and central Poole. It is also a pretty good location for those using the ferry terminal, and is also close to the RNLI Training Centre.

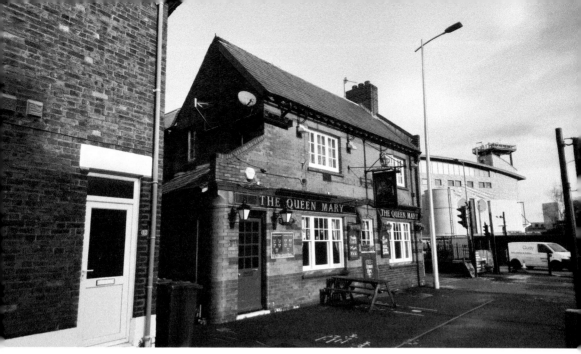

Above: The Queen Mary.

Right: The Queen Mary pub sign.

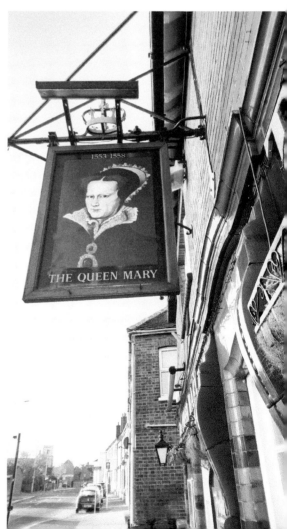

The *Barfleur*.

Poole Ferries

In 1974, the Truckline service was inaugurated to transport lorries and their cargoes to and from Cherbourg, France. This led to Poole becoming twinned with Cherbourg in 1977.

Later, Brittany Ferries introduced a passenger ferry, the *Barfleur*, which operates a daily scheduled service to Cherbourg, and then also introduced a freight line to Bilbao, Spain.

Meanwhile a high-speed ferry, *The Condor Express*, was also established, which runs services to Jersey and Guernsey, as well as St Malo in Brittany, France.

Commercial Shipping

Land reclamation has enabled expansion of the docks, which, in turn, has allowed greater trade between Poole and its twin town of Cherbourg and elsewhere.

Poole Harbour Commissioners have helped Poole to become a destination for cruise ships. A new deep water quay, which has a depth of 200 metres, has been constructed to accommodate cruise and cargo ships. This opened for business in the summer of 2018 and is one of the biggest developments seen on the south coast in recent years.

The development has enabled Poole to handle ships carrying over 1,000 passengers, as well as increasing the capacity to handle larger cargo ships. Sunseeker and other boatbuilding firms are also able to use this facility.

Poole Harbour Commissioners (PHC) are concerned with the management of all aspects of commercial and leisure activity in the harbour. This involves maintaining the shipping channels for both passenger ferries and commercial vessels. They ensure that the channels are dredged, that the bouys and lights marking the channels are maintained and provide pilots to steer ships in and out of the port. They also enforce speed limits and assist with nature conservation.

The green and yellow striped PHC boats are a regular sight around the harbour.

The Sloop, Commercial Road

The Sloop is opposite Poole Civic Centre and Poole Park. This land consisted of salt marshes and river tributaries before the land was reclaimed to become Poole Park in 1890.

The name is from a smugglers sloop that broke away from its anchor in a storm and was driven by the wind into a turnip field, situated where the pub now stands. The sloop was subsequently found to be full of barrels of French brandy.

The area became known as Sloop Hill, and the site opposite, which is now the Civic Centre, was known as Brown Bottom, and then after the development of Poole Park as Park Gate East.

Hall and Woodhouse have owned The Sloop since 1898, but prior to that it was an alehouse owned by Godwin Brewery, which was built in 1824.

During the early 1980s the pub was plagued by Hell's Angels, who were attracted by the live rock groups that played there.

In 1987 the name was changed to the Conjuror's Half Crown, which was in keeping with a Dickensian theme the brewery was keen on at the time – the conjuror's half crown features in David Copperfield. Hall and Woodhouse also had a pub called the Artful Dodger in Bournemouth at this time. In 2004, by popular demand, the name was changed back to The Sloop.

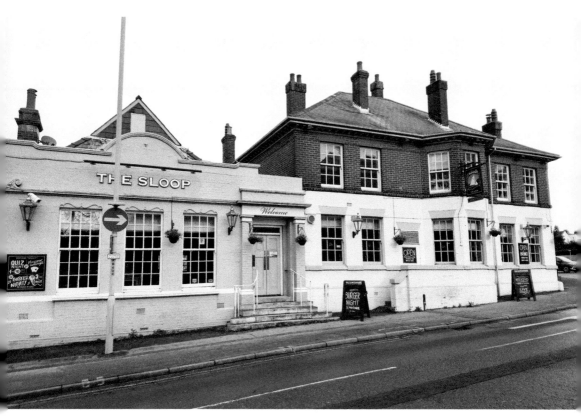

The Sloop.

The Sloop pub sign.

3

Pubs Just Beyond the Town Centre

Holes Bay, Holes Bay Road

The Holes Bay Table Table, to give it its full name, is a chain pub owned by Whitbread's, serving grill dishes and burgers, etc., which opened in 1996. It was built on the site of a former lighthouse, hence the feature of a mock lighthouse, and is on the A350. There is a Premier Inn next door, for which the pub provides breakfasts and evening meals.

The Holes Bay pub, as its name suggests, overlooks Holes Bay.

The Holes Bay.

Holes Bay

Holes Bay itself is a tidal inland lake that lies in the northern part of Poole Harbour.

In 2015, part of Holes Bay was designated as a European Marine Site (EMS), a Special Protection Area (SPA), and a Site of Special Scientific Interest (SSSI). It is also a RAMSAR site (Ramsar is the name of the town in Iran where the international treaty for the preservation of wetland sites of international importance for the preservation of birds was signed) and plays host to many nationally and internationally important species of birds.

The extensive areas of shallow waters and marshland make Poole Harbour an important bird migration route, as it has an abundance of suitable food in the form of shellfish. The sheltered and enclosed nature of Holes Bay makes it a particularly safe and secluded environment for birds and wildlife.

Birds that may be seen frequently are oystercatchers, wigeon and dunlin, as well as many more unusual species, and in the spring and autumn the mud flats dotted around the harbour can be full of birds stopping to rest and recuperate before migrating to warmer climates.

Fishing is not allowed in this area and there is also a seasonal closure between 1 November and 31 March for digging for oysters and cockles, or bait digging.

Holes Bay is also the location of the Royal National Lifeboat Institution Training Centre (see Royal National Lifeboat Institution (RNLI)) as well as a large marina known as Cobbs Quay on the Hamworthy side.

In Victorian times, Holes Bay had a pleasant esplanade that was a popular place for Victorians to promenade. A feature of interest was a cannon captured at Sevastapol during the Crimean War.

In 1985 part of the bay was reclaimed in a scheme to build the Holes Bay Relief Road or A350.

Holes Bay Nature Park.

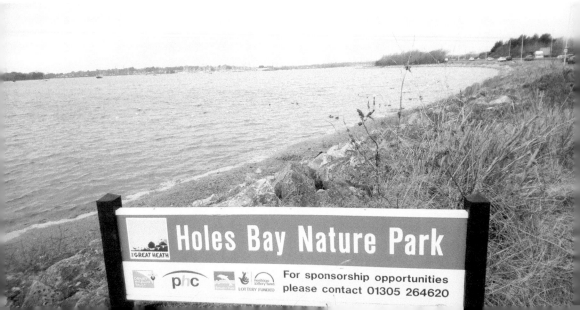

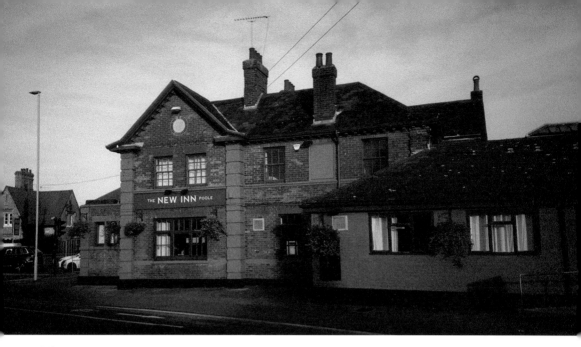

The New Inn.

The New Inn, Wimborne Road

The New Inn opened around 1820. It is situated at the junction of Wimborne Road and Fernside Road. It became an Eldridge Pope pub in 1900, having previously been a Styrings of Poole Brewery House.

In 1980, the pub had a period of being called the Hants & Dorset. The locals were distinctly underwhelmed by the name. Also, The New Inn is one of those pubs where the road junction is known by the name of the pub, so in 1986 the pub reverted to its former name in order to prevent confusion.

Salterns Hotel, Salterns Way

Salterns Hotel is situated adjacent to a 285-berth marina. The hotel incorporates a bar and restaurant, which has a large seating area outside providing pleasant views of the marina and harbour.

In the eighteenth century the area was active in the production of salt, and was originally called Salterns, but later changed to Lilliput. Some say the change of name was due to the connection with the smuggler Isaac Gulliver (see Notorious Poole Smugglers. Gulliver, Isaac).

Prior to the Second World War, Salterns was the location of a dockyard for a pottery firm, before becoming a yacht club and hotel called the Harbour Yacht Hotel. However, during the Second World War the site was the British Overseas Airways Corporation (BOAC) terminal for civil passenger flying boat operations. There were also military flying boat stations variously located at other points around the Quay, the main one being RAF Hamworthy.

At this time Salterns was Britain's only international airport and famous passengers have included royalty, test cricketers, various film stars and politicians including Winston Churchill.

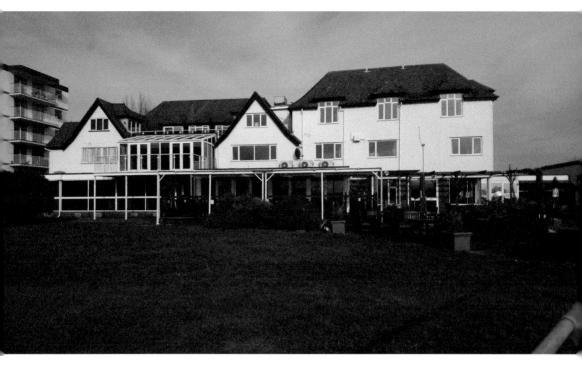

The Salterns Hotel.

The Salterns Hotel and marina.

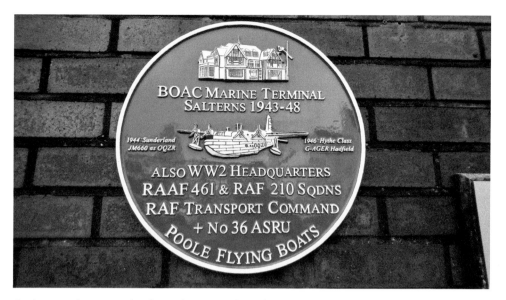

A plaque relating to the flying boats at the Salterns Hotel.

After the war it returned to its former use as a marina, and Poole Harbour Yacht Club took over.

The sea wall of the marina was created using remnants of the D-Day Mulberry Harbour (see D-Day), which was built in Poole.

In 1969 the hotel was bought by the Smith family, who had made their money from their business of Matchbox Toy Cars. They made many improvements to the site and developed the marina.

British Overseas Airways Corporation (BOAC) in Poole

As early as 1938, when war was imminent, Salterns was earmarked as a base to move flying boat operations to, as Poole was considered less likely to be on the receiving end of heavy bombing than the original base at Southampton.

British Overseas Airways Corporation (BOAC) was formed by the merger of Imperial Airways and British Airways in 1939, and in early 1940 flights from Salterns began in earnest.

On 3 August 1940, the first flight across the Atlantic by a British commercial airline was a BOAC flying boat passenger flight that took off from Salterns.

Throughout the war and until 1948, BOAC had 600 staff in Poole to support their various flight crews and flying boat services.

In addition to Salterns, other premises were requisitioned at Poole Pottery and on the Quay to provide backup services, such as administration and cargo storage.

The flying boats were moored in the water and passengers, mail and freight were ferried to them from launches. The flying boats then took off from the water. There were twelve high-speed launches, with sixty staff operating them.

Today Poole is recognised as the birthplace of BOAC and the forerunner of British Airways, although, after the war, the flying boats returned to Hythe in Southampton.

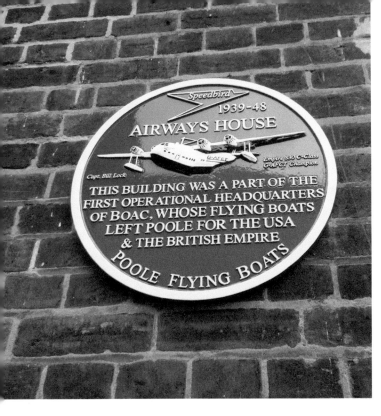

Another building that was used as part of the flying boat operation. This one is now the Tourist Information Office situated just off the Quay.

RAF Hamworthy

461 Squadron

The base for military flying boats was at RAF Hamworthy, which was rapidly constructed, and then commissioned in 1942. It became the base for 461 Squadron Royal Australian Air Force, known as the ANZAC squadron. There was a staff of 300 including crew and engineers.

The base didn't have any hangers for the aircraft, so maintenance had to be carried out on the hard standing.

In May 1943, 461 Squadron were transferred out. During their stay eighty-three personnel lost their lives. Their bravery and exploits are still remembered both in Poole and in Australia.

210 Squadron

In 1943, 461 Squadron were replaced at RAF Hamworthy by 210 Squadron. They became known as the Catalina Squadron due to their fleet of twelve American-built Catalina flying boats. They consisted of forty-six officers, 235 other ranks and twenty-one WAAF (Women's Auxiliary Air Force). They continued the vital work of their predecessors in spotting and sinking enemy U-boats.

One of the officers, John Cruickshank, was awarded a Victoria Cross. He was badly injured when sinking a U-boat in the Arctic, but then managed to pilot his badly damaged flying boat to the safe haven of the Shetlands.

In early 1944, 210 Squadron were moved out as RAF Hamworthy transferred to the Royal Navy and became HMS Turtle in the build-up to D-Day (see D-Day).

After D-Day it became a Royal Marines base (see Royal Marines).

Royal Navy Air Station Sandbanks
765 Squadron
In July 1940, the Royal Motor Yacht Club at Sandbanks became RNAS Sandbanks, home to Squadron 765 of the Royal Navy Fleet Air Arm, which relocated from Lee-on-the-Solent. It had responsibility for sea plane training and air sea rescue for the area.

RNAS Sandbanks had twelve seaplanes and a hundred personnel, but in the run up to D-Day, 765 Squadron was disbanded.

Today, the Royal Motor Yacht Club, along with the boat shed that was used for the flying boats, provide a poignant reminder of those times.

The Royal Motor Yacht Club at Sandbanks became the Royal Navy Air Station Sandbanks during the Second World War.

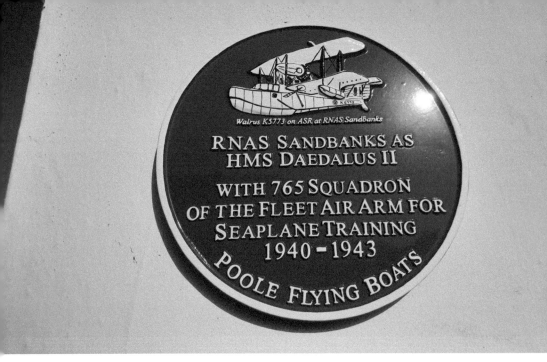

A plaque at the Royal Motor Yacht Club.

Shah of Persia, Longfleet Road

In 1869 a beerhouse occupied the site at the junction of Longfleet Road and Fernside Road. This was subsequently bought by Styrings Poole Brewery, who renovated the premises in 1876. The pub was named in honour of the Shah himself, who paid a visit to the south coast around this time.

The Shah of Persia.

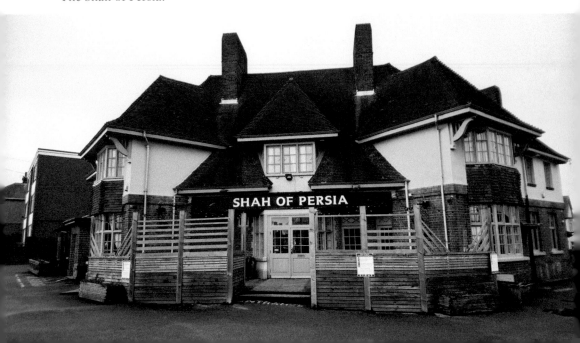

In 1931 a replacement building was erected behind the original, and then the original was demolished.

The Shah of Persia used to have a very unique and eye-catching pub sign, which was unusual in that it was four sided and featured several Middle Eastern characters in scenes that looked like something out of Arabian Nights.

In 1987 the Shah came second in a national steak and kidney pie competition. Other honours include the Eldridge Pope Champion of Champions Pub Quiz Team in 1993 and a mention in Egon Ronay's 'Good Food Public House Guide'.

Sweet Home Inn, Ringwood Road

The original building consisted of two houses, hence the name. It first became a pub in 1843 as the Rose & Crown. At this time it was licensed as an alehouse and was only permitted to sell beer and cider.

In 1888 it was rebuilt as the Sweet Home Inn, but was still only licensed to sell beer and cider, and this remained the case until 1951, when a full license was eventually issued.

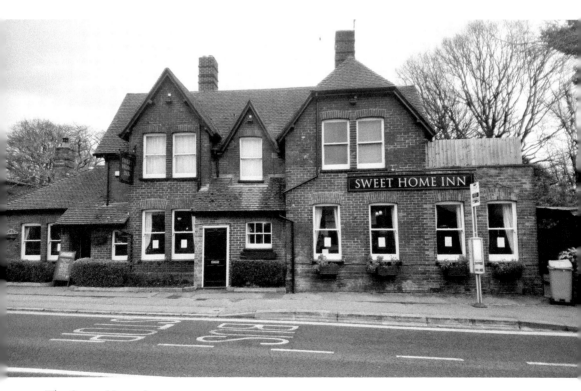

The Sweet Home Inn.

4

Hamworthy

Hamworthy is the more industrial part of the Quay, connected via the lifting bridge to the Poole side across the water.

The Hamworthy side has traditionally been the centre for boatyards and handling cargo. It also houses the ferry port and the new cruise dock (see Ferries and Commercial Shipping).

Boatyards

Ever since Iron Age man started building log boats, Poole has been a centre for boatbuilding.

The main manufacturer nowadays is the world-famous Sunseeker. However, several smaller boat yards also continue the boatbuilding tradition of Poole and Hamworthy.

Another prominent boatbuilding yard was Bolson's, who prolifically built landing craft during the run up to D-Day (see D-Day). They also built the cockleshell fold up canoes used by the Cockleshell Heroes (see Cockleshell Heroes).

The business eventually closed in 1998 and became part of Sunseeker International in 1999.

Sunseeker

The tradition of boatbuilding in Poole is nowhere more evident than at Sunseeker, who have been manufacturing high-performance motor yachts for the past fifty years and are one of Poole's greatest success stories. The company has won numerous awards including the Queen's Award for Enterprise.

The company was originally called Poole Power Boats and was founded in the 1960s by the Braithwaite brothers.

The company was transformed when Henry Taylor, a boat dealer and Formula One driver, asked for a boat with a full-length sun deck. This prompted Robert Braithwaite to design the Daycap 23, which was a cross between a motorboat and a family cruiser. Since then, Sunseeker has developed into a global brand, with large and glamorous vessels rolling off the production line for the world's rich and famous. They have even had starring roles in Bond movies.

Sunseekers roll off the production line.

Cargo

Poole has been an industrial port for many years, and until the mid-eighteenth century locally produced livestock, grain, vegetables, dairy produce, leather, wool and Purbeck stone were shipped to London and elsewhere. Poole Harbour clay was also supplied to the Staffordshire Potteries. However, the main source of income for Poole as a port at this time were various fees charged for using the port.

Today imports include timber, steel girders, gas lines, pipes, and palletized goods, whereas exports include clay, wheat, grain, sand, gravel and general cargo.

The markets for export and import include the Channel Islands, Europe, the Black Sea countries, North and West Africa and the Middle East.

Handling industrial cargo. Note the cruise ship in the background (see Commercial Shipping).

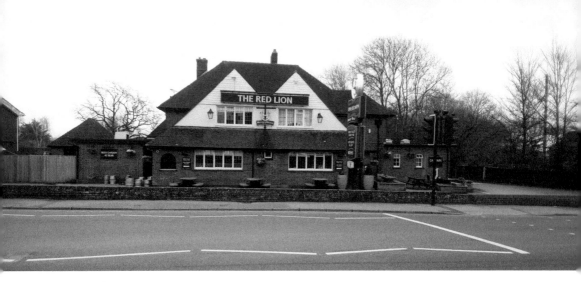

The Red Lion.

The Red Lion, Blandford Road

The Red Lion originally opened in 1817 as an alehouse. It was then rebuilt further along Blandford road in 1896. In 2008 the manager of the Red Lion and his partner managed to escape from an attempted arson attack. It is now part of the Greene King Hungry Horse chain.

The Yachtsman, Lake Road

In 1945, Hall and Woodhouse of Blandford purchased Pop Nunn's Café and Old Emporium in order to turn it into a pub. However, construction didn't begin until the late 1940s due to the paucity of materials after the war, and the pub didn't open until 1950.

The Yachtsman.

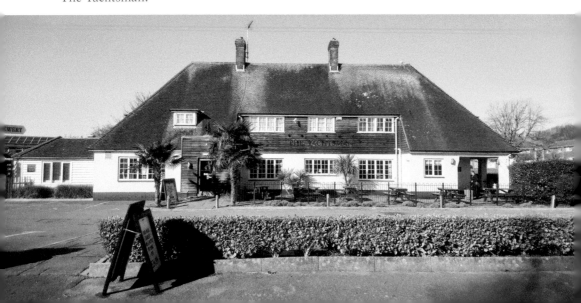

Hall and Woodhouse had made a wise decision as the pub became very prosperous. It was popular with workers from industrial premises nearby and those living in nearby estates, which at that time were mainly prefabs.

In 1951, a skittle alley was installed. This was subsequently removed, probably in the 1990s.

In 2004, the building underwent major refurbishment, with many fixtures and fittings removed and an extension built.

The Decline of Dorset Pub Skittle Alleys

Pub skittle alleys were once rife in Dorset, as they were elsewhere in the country, but they seem to be a declining tradition and yet another casualty of the changing pub culture eluded to at the beginning of this book. Breweries seem keen to take out skittle alleys in order to make more money per square foot in the form of restaurants or bed and breakfast accommodation.

Throughout Dorset teams have dwindled, and in the Borough of Poole there are no longer any skittle alleys within pubs.

Bibliography

Andrews, I., and Henson, F., *Images of England: Poole, the Second Section* (Tempus Publishing, 2000)

Andrews, I., *Poole* (Phillimore, 1994)

Burdett, D., *Poole: A Portrait in Colour* (The Dovecote Press Ltd, 2008)

Cullingford, C., *A History of Poole and Neighbourhood* (Phillimore, 1988)

Darvill, T., and Dyer, B., *The Book of Poole Harbour* (The Dovecote Press Ltd, 2010)

Guttridge, R., *Poole: A History and Celebration* (The Francis Frith Collection, 2004)

Hawkes, A., *A Pint of Good Poole Ale: Poole's Inns, Taverns and Breweries* (Poole Historical Trust, 2009)

Hawkes, A., *Book of Poole Quay and Waterfront* (Poole Historical Trust, 2013)

Levy, R., *The Book of Poole Harbour and Town* (Halsgrove, 2005)

Pulford, J. *Dorset Magazine*, Feb 2019

Richards, A., *Slow Travel Dorset* (Bradt, 2015)

Skinner, J., *Did You Know? Poole: A Miscellany* (The Francis Frith Collection, 2012)

The Scout Handbook (The Scout Association, 1973)

Poole Cockle Trail: www.pooletourism.com
Poole trail: www.pooletourism.com
www.purina.co.uk